DAVID PARK

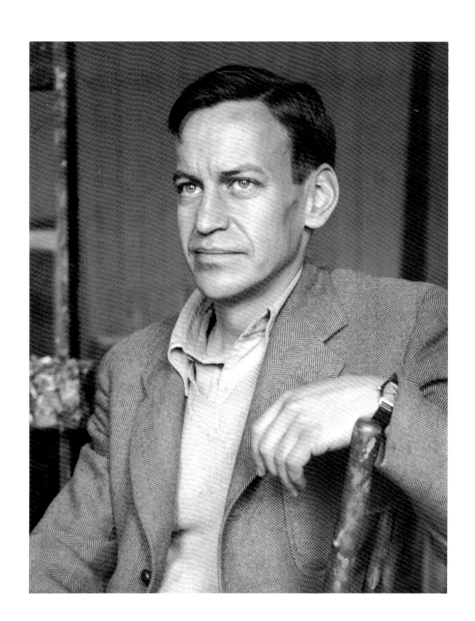

DAVID PARK

Richard Armstrong

Whitney Museum of American Art · New York
in association with the
University of California Press · Berkeley · Los Angeles · London

Exhibition Itinerary

Whitney Museum of American Art
November 4, 1988–January 15, 1989

The Oakland Museum
May 20–August 6, 1989

Cover: *Canoe*, 1957, detail (plate 37)
Frontispiece: David Park in the early 1950s

Library of Congress Cataloging-in-Publication Data

Armstrong, Richard.
 David Park/Richard Armstrong.
 p. cm.
 Bibliography: p.
 ISBN 0-87427-062-6
 1. Park. David, 1911–1960—Exhibitions. 2. Park, David.
1911–1960—Criticism and interpretation. I. Park, David,
1911–1960. II. Whitney Museum of American Art. III. Title.
ND237.P24A4 1988
759.13—dc 19 88-28064
 CIP

ISBN 0-87427-062-6 (WMAA paper)
ISBN 0520-06625-1 (UCP paper)
ISBN 0520-06624-3 (UCP cloth)

Printed in the United States of America

CONTENTS

ACKNOWLEDGMENTS

Reconstructing the chronological sequence and motives of an artist's life is a considerable challenge, one that can be facilitated with proper assistance. In the case of David Park, I have been helped by the Park family and many of the artist's friends. To Lydia Park Moore, Natalie Park Schutz, Helen Park Bigelow, Mrs. Richard Park, Mrs. Charles Cushing, Howard Baker, and Gordon Newell I owe much. Park's colleagues, principally Elmer Bischoff, Richard Diebenkorn, Tom Holland, Fred Martin, George Stillman, and James Weeks, candidly answered many queries. Paul Mills has been particularly generous in sharing his extensive knowledge of the era with me.

Many collectors of Park's paintings and drawings have kindly allowed me to study their holdings: Gerson Bakar, Rena Bransten, Peter Bull, Lois O'Brien and Ray Exley, Carol Field, Mordecai Kurtz, Allen Lubliner, and Mr. and Mrs. Glen Tobias, in addition to the lenders to the exhibition.

Commercial representatives of Park's work, including John and Gretchen Berggruen, Adrian Fish, Mark and Lauri Hoffman, Jan Holloway, Paul Kantor, and Penny Perlmutter, have shared needed information with me. William O'Reilly and Larry Salander of Salander-O'Reilly Galleries have been especially helpful.

I deeply appreciate the research assistance of Jeff Gunderson, San Francisco Art Institute; Eugenie Candau, San Francisco Museum of Modern Art; Arlene D. Rubin, Winsor School; and George D. Hickok, Loomis School. Christine Droll of The Oakland Museum gave me free access at critical moments to that institution's extensive Park collection. Other Park scholars, including Bill Berkson, Betsy Fryberger, Caroline Jones, Christopher Knight, and Susan Landauer, have also shared important data and insights about Park's work with me.

At the Whitney Museum, Denis Collura, Thelma Golden, and Ann MacNary deserve much credit for their labors in assembling material for the exhibition and catalogue.

The cordial generosity of the private collectors and institutional guardians of David Park's work reflects their enthusiastic wish that it be seen by a wider public. On behalf of the Whitney Museum of American Art and its audience, I thank them.

R.A.

FOREWORD

This exhibition of the work of David Park, the first museum retrospective in nearly thirty years outside California, offers us the opportunity to broaden our understanding of American art of the 1950s by examining the achievement of an innovative artist who was never closely associated with the New York art community. Born seven years after de Kooning and one year before Pollock, Park too began making art in the 1930s; but today, almost three decades after his death in 1960, he is still identified primarily as a "California artist." Like artists as diverse as George Segal and Fairfield Porter, Park decided early in his career to confront the historical role of realism. But as this exhibition confirms, he was also very much a part of the generation of artists for whom gesture and manipulation of paint were primary concerns. Park's singular amalgam of gesture and figure mark him as one of the most distinctive artists of the 1950s.

It seems odd that it was so difficult for an East Coast museum to secure significant funding to present Park's work. But the National Committee of the Whitney Museum of American Art realized that by bringing the work of a California artist to the Whitney Museum, they could assist in reducing the parochialism of the New York art community. Their collective assistance was reinforced by two individual members, Phyllis Wattis, an extraordinary patron who seeks to encourage creativity in all cultural aspects of life in San Francisco, and Nellie Taft, who pursues her own career as a painter in Boston. Their generosity has done the Whitney Museum and American art a great service. We are also grateful for the support of the National Endowment for the Arts, which historically, more than any source, has assisted the Whitney Museum in making American art more accessible to the public, often when other funding was unavailable.

This exhibition has required the curator, Richard Armstrong, to pursue the details of the life and art of the artist through an extensive search for Park's family, friends, and associates and through many subsequent conversations with them. It is their enthusiastic assistance which made it possible to organize this publication, which we sincerely hope will define the accomplishments of this remarkable painter.

Tom Armstrong
Director

This publication is supported by income from endowments established by
Henry and Elaine Kaufman, the Andrew W. Mellon Foundation,
Mrs. Donald A. Petrie, and the Primerica Foundation.

The exhibition is sponsored by the National Committee of the Whitney
Museum and the National Endowment for the Arts, with additional
funding from Nellie Taft and Mrs. Paul L. Wattis.

DAVID PARK
A PILGRIM'S PROGRESS

In 1961, the year after David Park's death from cancer at age forty-nine, the Staempfli Gallery in New York organized a retrospective exhibition of his paintings and drawings. The show then traveled to six other locations around the country, giving the widest exposure to date of Park's work, which had until then been little known outside California. Among the curious and appreciative audience was the painter and critic Sidney Tillim. Having seen the show both in New York and at The Corcoran Gallery in Washington, D.C., he wrote an assessment of the work that got to the heart of the Park issue: "to observe Park's development as an artist is to observe a raw, rootless talent patiently developing in an intractable environment."[1] The New York-based Tillim displayed a regional bias; he nonetheless touched on the central issue of Park's life: simply put, how to be a vital and inventive artist outside the New York milieu in the years after World War II.

Between 1945 and 1947 San Francisco had seen four important one-artist shows of recent work by Jackson Pollock, Mark Rothko, Robert Motherwell, and Clyfford Still; together, these shows chronicled the formative years of the style that would be known as Abstract Expressionism. David Park was one of many already established painters who converted to the style in the face of such compelling exposure. For three years he participated in the non-objective painting movement, but with pallid results. When he returned to figurative painting in 1949, he was confident about the rightness of his move. Yet in abandoning abstraction, he retained a gestural style: he spent the next ten years propelled by a desire to incorporate the freedom of gestural painting into incontestably figurative work.

Park's career can be seen as typical for a generation of artists that included Arshile Gorky, Pollock (in his 1940s work), and Willem de Kooning. Each in a different way sought a contemporary form of painting rich enough to exploit representationalism's definitive powers within the limitless range of personalized abstraction. But Park's work

Rev. Charles Edwards Park and Mary Turner Park, c. 1910.

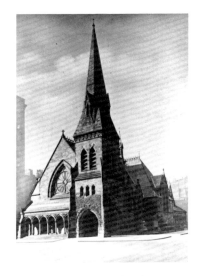

First Unitarian Church, Boston.

is atypical both in its complete removal from the intellectual and artistic forces of the postwar New York art world and in its insistence on the figure as the only subject.

David Park was born in 1911 in a brick townhouse in Boston's Back Bay.[2] He was the third of four children born to Reverend and Mrs. Charles Edwards Park. Reverend Park had been minister of the First Unitarian Church since 1907. It was a large and prosperous congregation, serving the affluent Back Bay area. Charles Edwards Park was himself the son and grandson of a minister. Although the Park household was dominated by Dr. Park's ecclesiastical schedule, religion seems to have played only a small role in the children's lives. Their recollections, instead, center on their parent's high spirits and devotion to one another. Parlor games, music (young David played the piano), and reading aloud from classic literature enlivened family life. Studying hard and achieving the best education possible were paramount in the Park credo; Dr. Park was a Yale graduate who hoped for a comparable education for his children. David, however, in contrast to his siblings, was at best a lackluster student.

When the First Unitarian Church closed for the summer, the Parks would go to Peterborough, New Hampshire. The large rustic house there was designed by Dr. Park, an amateur cabinetmaker who also built much of the furniture. Young David was especially happy in New Hampshire, roaming the woods and swimming, a sport that utilized his great physical stamina. The ancestral home in West Boxford, Massachusetts, was Park's other favored retreat, a place he and his brother Dick visited during the school year. These rural interludes supplied the unusually observant young boy with a store of visual memories to complement his city experiences of the well-ordered brick streets of Back Bay. Because David wore glasses until his teens, he was at a disadvantage in team sports, which may have reinforced his independent nature. His principal interests were drawing and painting, and by age ten (as his older brother recalled) David had decided to become an artist. One of his father's five sisters, Edith Truesdell, herself a painter, encouraged the boy by giving him a paintbox and professional advice.

In 1925, David's scholastic record led his father to enroll him as a boarding student at the Loomis School in Windsor, Connecticut, to remedy what Dr. Park perceived as a lack of

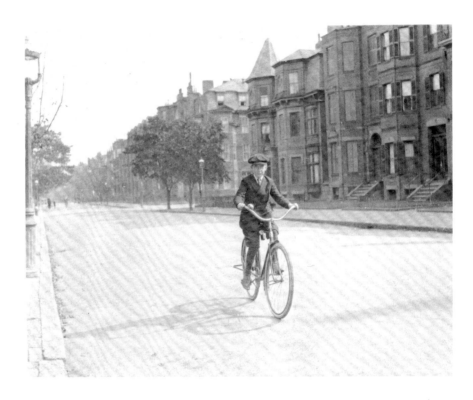

concentration. Although in later life David Park acknowledged the excellent education private school had offered him, he remained a sophomore after three years at Loomis; college was thus out of the question.

The Parks did, however, recognize the seriousness of their son's interest in art: during the summer of 1924 they had permitted him to stay with another aunt, Julia Park, and her artist friends at Lake Canandaigua, in western New York, in order to draw and paint landscapes. Many years later, another guest recalled a "sensitive, odd, charming boy" who wondered why she used such long words. "Looking back, I realize it was a critical time in his life. Frances Lee [another guest] was a good painter in both watercolor and oils; her friend Mary Gay painted well enough to have her oils exhibited in the Paris Salon. These two women and David made a delightful trio when they discussed their painting. Mary Gay watched over his work that summer and every now and then gave him a pointer. I remember the great satisfaction of the two elders when David was commissioned— for five dollars—to paint a neighbor's garden then in full blossom. And David's solemn and intense joy as he painted, as he completed the work, as it was approved by the patron, as he received the five dollars."[3] Photographs of his drawings from this period show a

credible realist artist, concerned with portraits and landscapes of the Back Bay and Peterborough. In the summer of 1925, Reverend Park and his sons built a studio with north windows for David at their country place. His work was sufficiently good to have been accepted for Boston's Society of Independent Artists in 1926 and again in 1927.

In the summer of 1928, Edith Truesdell invited David to join her and her husband in Denver, where they had stopped en route by car from Boston to Los Angeles. She proposed that her nephew accompany them to Los Angeles and enroll in the Otis Art Institute. The senior Parks agreed, and at age seventeen David left Boston to begin his life as an artist.

The Otis Art Institute was then a thoroughly academic institution featuring the usual life-drawing courses. Although Park evidently adjusted well to the routine of art school, Los Angeles was a relative backwater, and he moved to Berkeley in late spring 1929. At his aunt's suggestion, he audited summer school courses at the University of California.[4] There Park met Gordon Newell, a senior studying literature. Newell was struck by Park's determination to be an artist. When Park took Newell to the sculptor Ralph Stackpole's open-air studio in San Francisco's North Beach neighborhood, Newell instantly realized that he too wanted to be an artist. Stackpole soon hired both young men as studio assistants. Stackpole had studied at the École des Beaux-Arts in Paris and with Robert Henri in New

York before returning to San Francisco in 1914. He was at the center of a small group of progressive artists who advocated modernist ideas in opposition to the Impressionist landscape styles that dominated northern California painting in the years prior to World War I. Stackpole, who practiced the "direct cut" technique in stone carving, was hiring new assistants in 1929 to begin work on his largest commission to date—two monumental figurative sculptures that were to flank the broad staircase of the remodeled and enlarged San Francisco Stock Exchange. Park and Newell took a room in a boardinghouse on nearby Sansome Street and began working for Stackpole at $10 a week. Although Park made a few stone carvings during this period, he did not waver in his fundamental attraction to painting. Working in three dimensions, in fact, probably contributed to the strong illusionistic bent of his paintings.

Sometime later that year Newell's younger sister, Lydia, came from Los Angeles to visit the two young men in the small house they had rented on Telegraph Hill. Their bachelor housekeeping (Newell recalls that they lived mostly off of refuse from the nearby wholesale produce market) may have shocked Lydia Newell, a pretty twenty-one year old accustomed to her family's proper middle-class ways. But she and Park took to each other and, after visiting a few more times, the two were married in June 1930. Park took his young bride back to Boston to meet the family. By 1931, Park had completed his work for Stackpole at the Stock Exchange and moved with his wife to a flat in Berkeley; his in-laws moved into the same building.

As would be his lifelong habit, Park maintained a studio in the house. With the birth of his daughters, Natalie (1931) and Helen (1933), the apartment became cramped. But the young painter only found a part-time teaching job at a small private day school and the family remained too poor to change quarters. Park befriended the musical historian and Berkeley professor Charles Cushing soon after moving to Berkeley. His longtime interest in music gave them common ground; Cushing and his wife, Piquette, were but the first of a growing circle of faculty members who came to make up the Parks' set.

Park's job with Stackpole, which had eventually entailed working on the granite pieces outside the Stock Exchange, had afforded him a close look at the working method of the Mexican muralist Diego Rivera. After completing a highly praised mural in a new building of

the California School of Fine Arts, Rivera was invited to do another for a private dining room at the Stock Exchange, which he painted in fresco at the site, during Park's apprenticeship with Stackpole. Park also met the young sculptor Adaline Kent, who was working on a decorative commission at the Exchange. Her fiancé, Robert Howard (eldest son of the architect John Galen Howard), a scion of the Bay Area's most influential art family, was already Park's friend. Within a short time of his arrival in San Francisco, the young Park had therefore managed to join that city's liveliest group of artists.

Diego Rivera's impact on San Francisco's art community was immediate, profound, and long lasting. Although the social critique implicit in the Mexican master's celebrations of labor held little appeal for Park, Rivera's figurative, narrative compositions did influence the younger painter. In all Park's extant paintings of the 1930s he depicted common people, thus conforming to the political biases of his contemporaries. But his subjects, unlike the working-class heros of Social Realism, are at leisure—making music, lying down, dancing, bathing, eating, playing cards. However, the color and space of Park's paintings through the early and mid-1930s—the prevalence of flesh tones and the shallow bas-relief space—attest to the ongoing influence of Rivera and Social Realism on his work.

Park joined the WPA in 1934. With the completion of Coit Tower atop Telegraph Hill that year, the city had gained its first WPA-decorated building. Twelve of San Francisco's best-known artists created murals there about life in California—all in Rivera-inspired styles. Park was friendly with most of the Coit Tower artists. He himself worked on three other jobs: fresco lunettes for the John Muir School in San Francisco; tapestries for Piedmont High School in Oakland; and a mural for the University of California infirmary. The Muir pieces were in the prevailing Social Realist mode, incorporating scenes of labor and industry. By contrast, the Piedmont tapestries employ apolitical iconography from Greek mythology. Other Park work of late 1935–early 1936 included a series of architectural decorations commissioned for a new theater at Mills College in Oakland.[5] Never installed (probably never fully completed), they were intended as a classical history of music. Done on 8 × 10–foot plywood sheets and depicting Orpheus, Diana, Hermes, Bacchus, and other Greek mythological figures, they were to have been installed over the windows and doors of the theater.

The Curse of Cain, 1934,
from the *Genesis* illustrations.

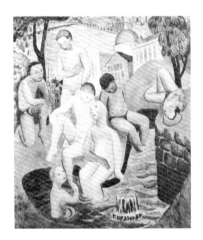

Boston Common, 1935
Tempera on canvas,
29 × 25⅛ inches
Private collection

In both the Piedmont tapestries and the Mills College commission, Park employed a figurative style more indebted to Picasso and Fernand Léger than to Social Realism. Dark schematic lines define subjects with saturated areas of underlying color that endow the work with an abstract air. These larger, commissioned pieces document stylistic experiments that Park began in 1934. Between 1934 and 1936, he illustrated about fifty miscellaneous Bible passages, ranging from well-known stories such as that of Ruth and Naomi to other, more obscure ones. He painted a number of these in watercolor on newsprint in the more advanced, Léger-like style. At the same time, he made a series of linocut stencils illustrating Genesis. These small-scale images were also stylistically related to the Mills and Piedmont commissions. The stencils, watercolors, and two commissions show a more sophisticated aesthetic—certainly one aware of Cubism and other modern tendencies—than do Park's tempera and oil paintings of the same moment.

These paintings, however, did gain in technical competence and in scale, their increased size facilitated by the Parks' move in 1935 to a rented house with room for a larger studio. In these pictures, languid, thick-limbed figures populate outdoor genre scenes. The most interesting, *Boston Common* (1935), features a multiracial group of children, bathing and resting on hillocks in the park. The picture is early evidence of Park's willingness to compose illogical space to enliven narrative—the domed statehouse, for instance, is depicted twice from different perspectives, while a wedge of Back Bay architecture introduces yet another visual territory.

Park's interior vignettes observe spatial conventions, but also reveal Park's inventiveness. As his color sense broadened, his compositions grew more complex. In such paintings as *Dancing Couple* and *Three Violinists and Dancers* (both 1935–37), Park elongates the figures' arms and torsos to enable their extravagant, intertwining gestures. If other paintings of the moment such as *String Quartet* (1936) and *Four People Drinking a Toast* (1935–37) are more compositionally staid, they nevertheless show Park experimenting with different implied vantage points. *Four People Drinking a Toast* is especially noteworthy for its truncated, close-up view—a device to which Park returned in later pictures. By working exclusively from imagined subjects (based on observation), Park avoided the kind of verisimilitude that might have mired his work in academic staleness.

Four People Drinking a Toast, 1935–37
Tempera on canvas,
26 × 24 inches
Private collection

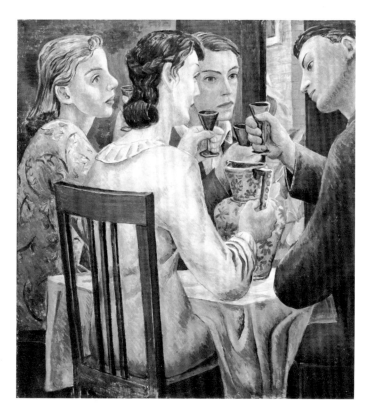

Dancing Couple, 1935–37
Tempera on canvas,
31 × 27 inches
Private collection

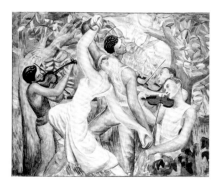

Three Violinists and Dancers, 1935–37
Tempera on canvas,
27 × 34 inches
Private collection

By late 1935, Park was a well-known artist in San Francisco, despite his youth. The previous year he had had solo shows at The Oakland Art Gallery (forerunner of The Oakland Museum) and at the avant-garde East-West Gallery in San Francisco. After joining the San Francisco Art Association in 1935, his work was included in the "55th Annual Exhibition" at the newly opened San Francisco Museum of Art and featured in a one-artist show there in 1936. The same year *String Quartet* won the Second Anne Bremmer Memorial Prize for Painting at the Art Association's "56th Annual."

Although during the first half of the 1930s Park worked both in a modernist-figurative and a Social Realist style, he had serious doubts about the touted dominance of Social Realism and about mural painting in particular, as he revealed in an interview with the *San Francisco Chronicle* in March 1935: "Contrary to many of my colleagues, I don't think easel painting is doomed. In the long run art is not functional, at least in our society. Ours is not the kind of world in which great mural painting can be done. . . . I do know that the isolated picture in its frame on the wall is as fitting to our day as any medium of artistic expression."[6] For a WPA artist in San Francisco

this bordered on heresy. Park was obviously trying to look beyond the Rivera model. The penchant for modernism already apparent in some of his work had been reinforced by his contact, beginning in 1933, with the art faculty at the University of California, Berkeley, where he taught an extension class in art. The Berkeley faculty had been championing European modernism since Hans Hofmann taught summer sessions there in 1930 and 1931. The preeminence of Picasso, central to Hofmann's perception of modernism, had been reasserted after the 1932 Picasso retrospective in Paris. Certainly, Picasso's figurative abstractions of the previous few years had attracted Park's close scrutiny.[7]

In 1936 Park moved his family to Boston so that he could accept a full-time teaching position, which one of his aunts had arranged for him at Winsor School, a girls' school in Brookline. He felt qualified since, besides the University of California extension classes, he had also taught art in 1934–35 at Bentley School in Berkeley, a day school mostly serving faculty children. He may have felt that leaving the San Francisco area would complete his break with Social Realism; moreover, the Winsor salary better supported his family. In Boston, the Parks found a temporary apartment in Brookline before moving to a house in Cambridge that would be home until 1941. Most of Park's siblings lived in the Boston area and his parents were still at the Marlborough Street home in which Park had been raised. The David Park family was quickly assimilated into the larger Park clan, attending the First Unitarian Church and summering with the rest of the family in Peterborough. At Winsor, as at Bentley, Park taught art and directed plays. An alumni bulletin from 1940 describes the work of the art classes then on exhibition throughout the school and apparently done under Park's supervision. The subjects included: "The Seven Ages of Shakespeare, the family on relief, the mural panels representing the arts, music, architecture, dancing, painting. . . . The mural borders in the dining room depicted in the fall sources of food, with the Boston harbor and a fishing scene on one wall, a farmyard scene and a milk wagon on another, a wheat field on another, an orchard on another; in the spring a mural made by another class showed typical sports of the different seasons."[8]

But in his own studio Park had moved decisively away from such allegorical or Social Realist works. After arriving in Boston he began

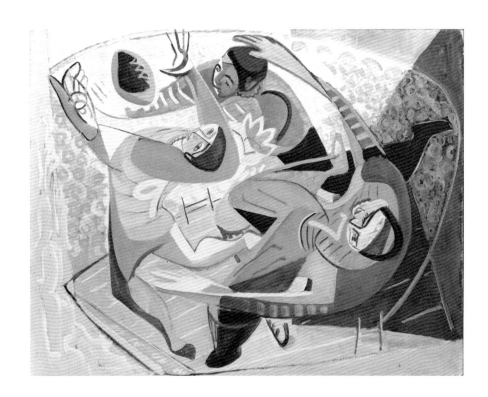

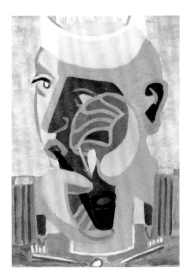

to paint in a manner indebted to the still lifes, artist-in-studio and puzzlelike figurative paintings that occupied Picasso in the early 1930s. These are Park's first mature works. One of the earliest, *Man with Pipe* (1936), embodies his newfound affinity for the flattened and more abstract space of modern art. A small and intensely colored work, the painting also signals a bolder, almost Fauvist taste for color that would characterize his late 1930s work. The sweeping movement of Park's earlier gesturing dancers or musicians is reduced and simplified into interlocking arcs and planes that schematically add up to the figure's face and hands. Although essentially still a figurative conception, *Man with Pipe* is a critical aesthetic advance over Park's San Francisco paintings.

As he continued in this new, Picassoesque idiom, Park enlarged the size of his pictures. *The Football Game* (1937–39), nearly twice the size of any of his preceding works, also exemplifies Park's new ambitions, namely, to balance the inherent narration of figurative subjects with more formal concerns. Thus, the players' contorted postures as they struggle, arms outstretched, for the football establish a counterclockwise spiral so graphically acute as to overpower any depiction of a rationally locatable game.

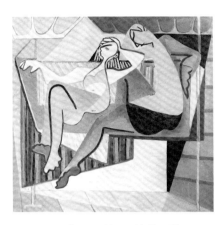

Composition with Two Figures in a Swing, 1937–39
Oil on canvas, 40 × 41½ inches
Private collection

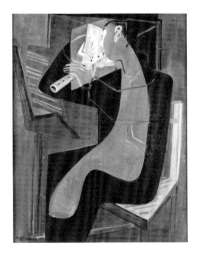

The Flutist, 1939
Oil on canvas, 34 × 27 inches
Private collection

Comparable anatomical liberties distinguish *Composition with Two Figures in a Swing* (1937–39), clearly derived from Picasso. A couple sprawl across a swing, their schematic features defined by sinuous dark lines. The ambient architecture is rendered as a patterned, orthogonal simplification. This kind of radical renunciation of naturalistic depiction in favor of abstraction is advanced further in such paintings as *The Flutist* (1939). Here Park metamorphoses the figure into an amoebic boomerang shape. The musician's profile and playing hand are highlighted in white to form an otherwise unapologetically abstract treatment of a subject already familiar in Park's oeuvre.

After showing his earlier, more representational pictures at Delphic Studios in New York in 1936, Park presented the more abstract paintings at the New Gallery in Boston in 1939 and in small, one-artist exhibitions at the San Francisco Museum of Art in 1939 and 1940. Despite the stylistic changes, his subject remained the figure, as the paintings' titles made clear: *Seated Figure*, *Violinist*, *Mother and Child*, and *Composition with Two Figures in a Swing*. From his beginnings, Park had been a representational artist. Working from his imagination may have allowed him greater formal latitude than painting from the model, but even at his most radical, Park focused his work on the figure. He used Picasso to supersede the limitations of Rivera and Social Realism, but much like his peers in New York (such as Arshile Gorky), Park found that getting beyond Picasso and the conventions of late Cubism presented another, even greater, challenge. Ironically, like Picasso himself, Park moved from abstraction toward the subjective representationalism of Surrealism. The influential traveling exhibition "Surrealism and Abstraction," organized by The Museum of Modern Art in 1938 (seen in San Francisco in 1941), may have brought Joan Miró to Park's attention. In any case, his Picassoesque style was about to give way to a more Surreal and introverted vision.

In the fall of 1941, Park and his family moved back to Berkeley. His wife missed her aged parents, and they both missed their Berkeley friends. The thirty-year-old Park may also have felt that changing locale would again facilitate the evolution of his work. For a few months they lived with the Newells on Richardson Road, then

through friends they located a large Arts and Crafts style house on Santa Barbara Road in Berkeley. At $40 a month, it was a bargain, even if structurally precarious: the hillside and the house were slowly sliding, so that the doors would not shut and the house's stairs, floors, and ceilings were out of plumb. But with its big side veranda and generously sized rooms (including four bedrooms), it offered the Parks their first comfortable home.

America's entry into World War II interrupted Park's artistic progress. Ineligible for the draft because of his age and that of his children, he worked as a machine operator at the General Cable Company in neighboring Emeryville. Lydia took a job at the University of California Press, with sister-in-law Iste Park (her husband, Dick, stationed nearby) caring for the children. Upon leaving General Cable each morning after a midnight-to-eight shift, Park would go to a temporary studio he rented in a storefront near Berkeley High School. He would then go home to rest and eat. His artistic output in this period was meager and was further slowed in 1942 by an accident in which a heavy load pinned him against a wall, breaking several ribs. But he relished the labor environment and remained at General Cable until the end of the war.

Through this period, new friends, such as Mark and Ruth Schorer, as well as his old friends Howard and Dorothy Baker, who came out from Harvard, joined the Parks' social circle, which remained an academic one. Park reintegrated himself into the San Francisco artists' community, rejoining the Art Association and taking part-time teaching jobs at the Oakland Art Gallery (children's classes), the San Francisco Museum of Art, and the California School of Fine Arts.

Looking at Park's work of this period, it seems that his self-imposed task was to revitalize his favored subject, the figure. He chose to concentrate on its most expressive component, the face, in a series of small profile paintings he referred to as "masks." Though the first of these pieces was done in encaustic, he had to return to the oil medium because war-induced shortages kept the fuel needed to heat the wax in short supply. Even so, this use of thick, heavily worked paint was new, since Park's previous work had been uniformly thin. He now knifed on the surfaces, as if to mold his imagery. Certain of the mask paintings, like *Woman Holding Flower* (1944), incorporate other motifs with the requisite faces; these are the most blatantly

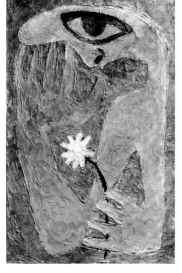

Woman Holding Flower,
1944
Oil on canvas, 18 × 12 inches
Collection of Mrs. Charles C. Cushing

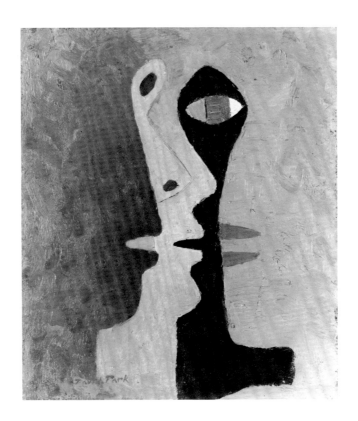

fantastic of the new works. The amoeboid shape of *The Flutist* or the undulating contours of Park's biblical stencils reappear here, filtered through the psychologically charged naturalism of Miró or Jean Arp.

Other mask paintings are sophisticated inquiries into illusionist figure-ground relationships. Among the most spatially ambiguous of these is *Three Profiles* (1944), where a ground color shifts from dark to light while configuring into three undulating, abstracted visages. Formal abbreviations such as ovals and amoeboid shapes establish, then contradict, the interlocked profiles. These small, whimsical paintings are more like intellectual or spatial exercises than significant pictorial achievements. They are modest, but Park seems not to have been dissatisfied, showing them at various group exhibitions at the San Francisco Museum and at a one-artist show at the California Palace of the Legion of Honor in 1946. Yet these mask pictures were ultimately instructive for Park alone: they encouraged his growing taste for the intrinsic value of paint handling, and he used them to reintroduce a spatial ambiguity not present in his Picassoesque works.

In 1945, Douglas MacAgy assumed the directorship of the California School of Fine Arts. One of his first acts was to cover the Rivera mural with a sheet. One of his next was to ask Park, along with painter Hassel Smith and, later, Elmer Bischoff, to join the faculty on a full-time basis. Entering into his maturity, Park was about to encounter there the full force and persuasion of abstract art as incarnated in Clyfford Still, and to surround himself, for the first time, with a group of ambitious and very talented artists.[9]

The school that MacAgy took over in 1945 was practically moribund, having lost enrollment steadily through the 1930s and precipitously during the war. A native Canadian who had studied in London and worked at the Cleveland Museum of Art, MacAgy arrived in San Francisco in 1941 to work as Grace McCann Morley's assistant at the San Francisco Museum of Art. When MacAgy accepted the CSFA job, it was with the understanding among its trustees that he could do whatever he felt was necessary to revive the institution. The school quickly profited from the flood of young veterans coming home to study under the G.I. Bill. MacAgy had no patience for committees, nor would he brook any bureaucratic hierarchy—students were simply younger artists than those on the faculty. Both groups were encouraged to arrange their classroom schedules around the demands of their studios, rather than the customary reverse. Faculty meetings took place over cocktails at the MacAgys. It was an unusually free method, presided over by the brilliant and autocratic MacAgy.

Although lacking a high school degree, Park had considerable teaching experience and was a logical choice in MacAgy's drive to get a younger and better staff. Hassel Smith was an alumnus of the school and had been working there as a substitute lithography instructor when MacAgy arrived; Bischoff, a University of California graduate, was hired in the winter of 1946 as a last-minute addition. The three became good friends; they criticized one another's work and were collectively invigorated by the good fortune of being part of what was already an extraordinary time at the California School of Fine Arts.

Clyfford Still arrived at the school in 1946, dressed in a long black overcoat and bearing snapshots of some of his recent abstractions. This was Still's second residency in San Francisco, having lived there from 1941 to 1943. Still's radical new paintings—opaque fields of what seemed to be shards, coursed over by eccentric

streaks of light and fragments of lush, dark color—impressed MacAgy even as photographs, and he recalled having seen reproductions of them in national art magazines. MacAgy hired Still. Some months later, MacAgy's wife, Jermayne, acting director at the California Palace of the Legion of Honor, organized a show of Still's recent work that would take place in 1947.

The show consisted of thirteen recent paintings, immense by contemporaneous standards (averaging 6 × 5 feet), of Still's peculiar flamelike fields of shattered color. A student of Still expressed the amazement of younger artists: "Most of us, veterans of the Second World War, had stern convictions as to the nature of modern painting; it must be Mondrian, Miró, or Picasso. What we were confronted with on the walls of the Legion Museum was unrelated to these preconceptions—unrelated in the most upsetting fashion. . . . Still's works were marked by a violence, a rawness which few of us—though we naturally accepted the violence of the current Europeans—were prepared to recognize as art. It was unnerving to have one's preconceptions so efficiently shorn in a single exhibition. Here was painting that instructed even as it destroyed; the School of Paris had died quite suddenly for us; something new, something most of us could not yet define, had occurred."[10]

Still is thus regarded as the catalyst for this "destruction" of the School of Paris in Bay Area art. And indeed, his dramatic personality, radical paintings, and his residency in San Francisco combined to make his presence there unnaturally large.[11] But too much has been made of his supposed influence on Park; though they were colleagues for four years at the California School of Fine Arts, Still's flamboyance and his followers' cultish behavior offended Park.[12] Moreover, other vanguard New York artists had already been shown in San Francisco to much acclaim, including Pollock in 1945 and Rothko in 1946.

Still's work did, however, liberate other San Francisco artists. Hassel Smith, among others, abandoned his narrative, figurative style in favor of a gestural, abstract way of working that better suited his mercurial temperament. Elmer Bischoff, though initially attracted to Rothko's pictographic style, soon moved on to a more gestural mode. Richard Diebenkorn, a young vet who had enrolled at CSFA in 1946, was befriended by Park soon after arriving. An unusually gifted student, he painted in an abstract style derived from Picasso and

Untitled, 1947–48
Oil on canvas, 74 × 36
inches
Destroyed

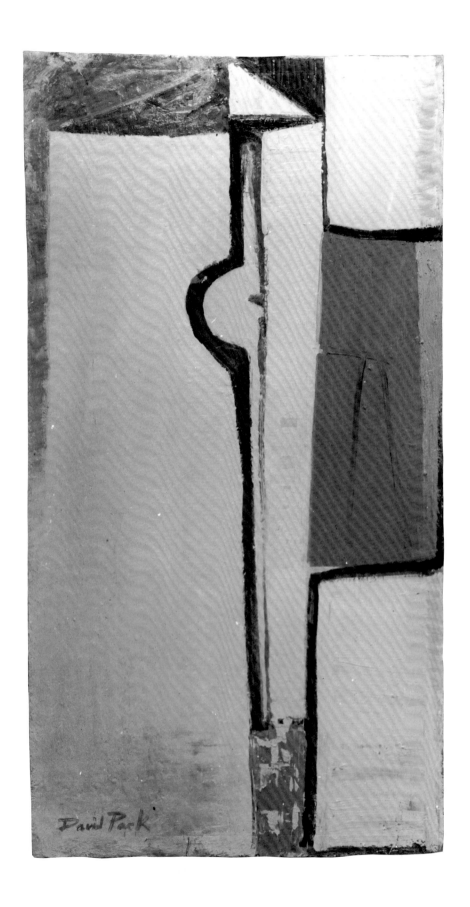

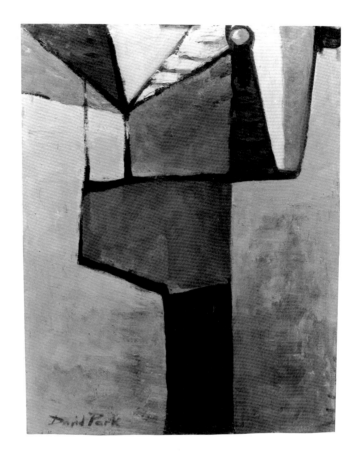

Untitled, 1947–48
Oil on canvas, 60 × 48
inches
Destroyed

Miró—Park's own models. It was Diebenkorn who reinforced Park's enthusiasm for the work of Robert Motherwell, which Park had seen in the spring of 1946 at the San Francisco Museum of Art. Park seems to have begun his first non-objective paintings sometime late that year.

The few photographs that remain of Park's non-objective works (most were destroyed in 1949) show Park's careful observation of Motherwell's own evolution out of Synthetic Cubism into a more organic, personalized mode. This Cubist heritage can be seen, in part, in the many collages that occupied Motherwell in the 1940s—slabs and ovals of flattened color and texture interlocking to make a composite whole often suggestive of human figures.

Park quickly adopted a larger format for his compositions (by 1947, paintings 6 × 3 feet were not uncommon), which featured eccentric shapes of color that look diagrammatic, sometimes cohering to form plinthlike structures. As in Motherwell's work, this is a flat planar space in which dark lines separate broad areas of color, with white a dominant hue. Park retained his interest in paint application, layering paint for a blistered surface. (To afford this abundance of

paint, he used housepaints.) His concern for complete integration of color and form, inferred in the masks, became paramount. In their adherence to a shattered, gridded space, the paintings of both Motherwell and Park connect to Picasso. In Park's case, they are almost enlargements and improvisations on the patterned, orthogonal elements of his late 1930's works.

In the summer of 1948 Bischoff, Park, and Smith were honored with a three-artist show of their recent work at the San Francisco Museum of Art. Fred Martin, a first semester student at CSFA, published his recollections of the show many years later: "but the paintings there of David Park, their texture, their color, their grand simplicity of shape—I still remember the largest of all, a vast horizontal in deep green with scattered, running, wide strokes of muddy red and in an upper corner, turning, a fragment of black, like arms and the structure of a crane with the yellow of an afternoon sky behind it."[13]

The show was generally well received and Park continued in his non-objective vein. A 1948 course description that Park wrote for CSFA shows to what extent he appropriated the gestural spontaneity that had become the hallmark of the new abstraction, in New York as well as San Francisco.

> *Line Drawing: The line drawings in this class are made in thirty seconds or a minute. Subjects are called out by the instructor and the students are timed. Subjects include landscape, figures, insects, architecture, illustrations of poetry, myths, memory drawings from the model, etc. The emphasis is on the use of imagination. Speed is used to combat hesitancy. . . .*[14]

But he also taught a class called "Reality in Representation," described as an "introduction to the problems of pictorial representation"[15]—hardly a task that a thoroughly non-objective artist would have accepted.

Park admired the fanciful calligraphy that distinguished Hassel Smith's works of this moment. He owned Smith's *Alone with the Killer* (1948), but could not infuse his own work with its playful quirkiness. Instead, his abstract style seems to have deteriorated into a clotted incoherency, as in the belabored painting *Untitled* (1948). Diebenkorn later felt that Park's work in this period was "kind of forced . . . he

Hassel Smith
Alone with the Killer, 1948
Oil on canvas, 20 × 22
inches
The Oakland Museum,
California; Gift of Mrs.
David Park

Untitled, 1948
Oil on canvas, 72 × 60 inches
Destroyed

Still Life—Non-Objective, 1949
Oil on canvas, 34 × 25 inches
The Oakland Museum, California; Gift of the Women's Board

was involved with shape but I never felt there was a terribly important space to his non-objective work. . . . There would be shapes without a good reason, there would be shapes which *were* representational—they were awkward and got in the way."[16] One of Park's few surviving non-objective paintings, *Still Life—Non-Objective* (1949), exhibits the weakness Diebenkorn perceived. Decipherable as either a still life or a head, the picture is ultimately turgid, heavy, and overworked. Though handsomely colored, it is an unconvincing mélange of impastoed gesture and overly descriptive line drawing.

Park was surrounded at the California School of Fine Arts by younger artists (the best of whom included Ernie Briggs, Edward Corbett, John Hultberg, Frank Lobdell, and George Stillman) who had adopted Abstract Expressionism with a ferocity and authentic ease that must have daunted him. When, unlike most of them, Park's work was not selected for an annual exhibition at the Legion of Honor, his dissatisfaction with the non-objective style seems to have been confirmed.[17]

With characteristic directness, Park determined to return to figurative subjects, the way of working he knew best and whose merits continued to impress him daily in class. Sometime in late summer-early autumn 1949, he loaded his car and its running boards with as many of his non-objective paintings as could fit, drove to the city dump, and disposed of the lot. Only a few of the paintings remained, and most of these were painted over or subsequently destroyed. Park meant to start anew.

Writing about his radical shift four years later, Park assessed his previous twenty years' work from the vantage point of an abstract artist. Although his allegiance to non-objective painting was in fact quite brief, he earnestly believed himself to have earned his credentials as an abstractionist—a reflection perhaps of abstract art's overwhelming dominance in the early 1950s. He underscores his break, both from his own past and from his contemporaries, in the statement's first two sentences:

The reproductions on these pages are from work done in the past three years. I call them pictures. The work that I have been doing previously I called paintings. They were non-objective, before that abstract, and earlier still they were highly stylized compositions not directly concerned with representation. For more than twenty years I

Hassel Smith and Richard Diebenkorn in David Park's studio, 1949.

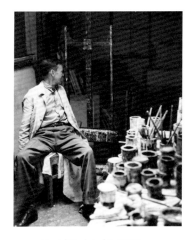

David Park in his CSFA studio, c. 1948.

had preferred other qualities to those of representation.

During that time I was concerned with the big abstract ideals like vitality, energy, profundity, warmth. They became my gods. They still are. I disciplined myself rigidly to work in ways I hoped might symbolize those ideals. I still hold to those ideals today, but I realize that those paintings practically never, even vaguely, approximated any achievement of my aims. Quite the opposite: what the paintings told me was that I was a hard-working guy who was trying to be important.

In telling this I am purposely stressing my own reactions to my own paintings. Other people's reactions seemed to me to vary in all degrees from enthusiastic to bewildered to positively negative. All of them were influential and challenging, but none of them held a candle to the insistence of my own reactions. To me it was clear that when I aimed to fulfill the grand ideals all that the painting did was to record the vulgar gesture of a finger pointing. Was it possible that they did not want to be pointed at or were the ideals putting me inextricably in my own way?

Gradually it dawned on me that my attention was always being drawn from the painting and directed to the painter. The fact is I had taught myself to use the painting as a means of looking at and trying to appreciate the man who did it. This was contrary to another strong ideal which said that a man's work should be quite independent of him and possibly very much more wonderful.[18]

As Park notes, his dissatisfaction with the late 1940s paintings was twofold: they fell short of his "aims," and secondly, he disliked the egocentrism he found implicit in Abstract Expressionism. The first contention must be accepted at face value, whereas the second seems a retrospective rationalization of his aversion to Still and his followers.

Park's claim that for more than twenty years he sought qualities other than representation at first seems jarring, given his deep, fundamental loyalty to figurative art throughout the period. Perhaps he perceived his post-Social Realist work as a real break from purely representational concerns. But he had made this break at the expense of subjecting himself to other influences: principally Picasso, but also Miró and gestural abstraction. It was only with his return to figuration in 1949 that he was finally able to establish a more inner-directed aesthetic standard.

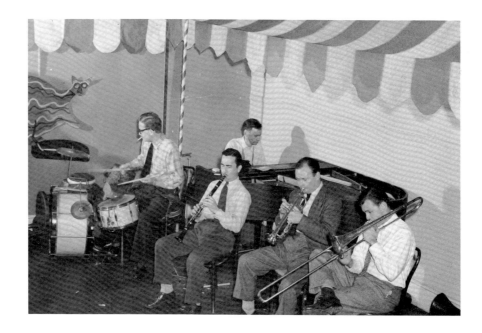

Park's reaction against non-objective painting was so intense that he returned, at least initially, to the intimate scale and impasto renderings of his 1940s masks. One of the first of his new paintings was *Rehearsal* (1949–50; Pl. 1), which portrays the "Studio 13" jazz band that Park had helped organize among faculty and students at CSFA. Park played piano for the Dixieland group, Elmer Bischoff the cornet and, for a while (as seen here), MacAgy was the drummer. *Rehearsal* is an early and somewhat clumsy exposition of Park's renewed use of narrative. At the same time, he consistently brought subjects to the edges and front of his pictures, denying the privileged, judgmental position of the spectator by collapsing the distance between the spectator's space and that of the image. We are, in effect, thrown into the activity of the picture. The figures in *Rehearsal* are viewed from over the pianist's unseen shoulder at lower left, with his instrument leading the eye into the background. The bass looming up at the right and its player's cocked arm and head reiterate our over-the-shoulder vantage. A comparable effect of telescoped intimacy—here almost one of eavesdropping—takes place in *The Letter* (1951; Pl. 6). Park's friends Howard and Dorothy Baker are seen reading a comically plaintive note he had actually sent to their children, in which he asked why their parents read the youngsters' mail. Park knowingly makes the viewer into a visual eavesdropper in an attempt to activate an otherwise mundane narrative.

Further spatial experiments include *Table with Fruit* (1951–52; Pl. 7), a painting of a family dining. Though spatially somewhat forced in its attenuated perspective, this poignant picture of domesticity falls within the intimist tradition of such Post-Impressionists as Felix Vallotton and Édouard Vuillard. The deeply receding space exaggerates the distance between the man at the head of the table and the girl at the other end (possibly Park and his daughter Natalie). Park darkens their features, which has the effect of making the colorfully dressed mother figure at the left a more emphatic presence.

Park freely exploited the implied psychological insights of these early narratives in other more overtly veristic works such as *Portrait of Hassel Smith* (1951; Pl. 5). Here for the first time Park translated some of the liberties he had allowed himself as an abstract artist into his representational work. A small *tour de force*, the painting exploits gesturalism and a palette of high-contrast colors. As always, Park's method was to scrutinize the subject and then paint from recollection. Smith's florid complexion and distinctive head lent themselves to Park's new taste for expressionist portraiture. The abstract welter of Smith's boldly patterned shirt anchors him to the picture's right corner, his arching neck and outstretched right hand orienting the image toward an abstract sliver of outdoor reality glimpsed beyond a white window frame. The slabs of color defining the room and the cut-in window are reminiscent of his planar, Motherwell-derived works of 1946–49.

Less adventurous but no less important are paintings such as *Untitled* and *The Beach Ball* (both 1950; Pls. 2, 3), which demonstrate Park's efforts at inventing a shallow space as receptive to his figures as the illusionistically deep space in paintings like *Rehearsal* or *Table with Fruit*. Park elaborates the knifed-on impasto of his masks and brings forward, enlarges, and radically crops faces to vary the depth of each painting as much as possible. Moreover, both settings are indistinct— the vaguely urban atmosphere of *Untitled* and the implicit seaside of *The Beach Ball*—which makes the two pictures significant for their formalist rather than depictive or narrative impulse.

The same could be said for *Kids on Bikes* (1950; Pl. 4), the first of Park's new paintings to attract public attention. When *Rehearsal* was shown in a group exhibition at the de Young Museum in March 1950 it seems to have provoked almost no comment. Though completely unlike anything Park had shown since his return to San Francisco nine

years earlier, *Rehearsal* may have been seen as a humorous anomaly done to celebrate the "Studio 13" jazz band, by then a well-known art world fixture that played at parties around the Bay Area. By contrast, the reaction to *Kids on Bikes*, shown in the Art Association's "70th Annual Exhibition" of 1951, was widespread. The jurors awarded it a prize (along with other, more orthodox abstract works), and it was reproduced in the Art Association Bulletin as well as in a national art magazine.[19]

An ordinary, if completely imagined scene, the cartoonish drawing of *Kids on Bikes* is a sharp reaction against the increasingly theoretical, even simplistically metaphysical dialogue that thrived in Abstract Expressionist circles. The earnest commitment of Park's abstractionist friends and colleagues was mocked by the awkward informality of this painting. Diebenkorn, one of many who disliked it, thought it fundamentally flawed because it was "pre-Abstract-Expressionist."[20] Park again brings some images to the fore while exaggerating the recession of others, so that our eye passes over the dominant striped-shirted boy at left to rest on the much smaller figure seen from behind, wobbling on his bike. A broad central path of orange recalls the blistered surfaces of Park's abstractions, while the patchwork of olive and black at right, overlaid by a tangle of incised calligraphy, is intended as an abstract reconstitution of nature. Something like the stippled marks of Hassel Smith's shirt, this passage augurs Park's later, more thoroughgoing adoption of gesturalism to his figurative cause.

Park's return to figuration was done in isolation, both geographically and artistically. His sole counterpart at this time was Willem de Kooning, who in 1950 began his Women series. During the five years that this series occupied de Kooning, the female form was subjected to relentless reconfigurations. But as his subsequent return to more abstract painting revealed, de Kooning had used figuration to reinvigorate his abstraction. Park, on the other hand, had returned to representational painting as a reaction against both his own less than satisfying work as an abstract painter and what he saw as the egocentric excesses of Abstract Expressionism. Moreover, the careers of the two artists took divergent paths: whereas de Kooning's Women paintings were rapidly acclaimed in New York, Park's new work met with hostility in the San Francisco art world.

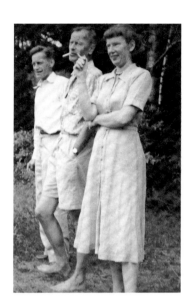

David and Lydia Park with
a friend, September 1953.

By 1952 Park's personal circumstances had changed. Not only had Diebenkorn left the California School of Fine Arts for graduate school, but MacAgy had resigned in 1950. The school's new administration was less sympathetic to Still's continuing dominance and sensitive to its decreasing enrollment as G.I. Bill students moved on. When Hassel Smith was let go in 1952, Park and Bischoff resigned from the faculty in protest. Concurrently, the Park's rented house was finally destroyed in a mudslide, forcing the family to take a small apartment. Lydia's job at the university library became the couple's primary means of support. David later referred to her breadwinning as his "Lydia Park Fellowship" years, since his own attempts earlier in the decade to supplement his teaching salary by designing wallpaper and doing liquor store displays (among other jobs) had proven unprofitable.

Working in the living room of their apartment (dutifully cleaned each evening for his wife's return from work), Park painted a series of bold, densely populated paintings that show his dual concern with varying eccentric spatial formats and, more important, with intensifying the color contrasts of his work.

Despite his cramped quarters (or perhaps because of them), Park painted his busiest, most crowded paintings yet: *Bus Stop* and *Cocktail Lounge* (both 1952; Pls. 8, 9) pack people into confined surfaces. The natural orange and white light of *Bus Stop*—a street scene focused around an upright "Coach" sign—and the artificially blue light of *Cocktail Lounge* show two extremes of his palette, which remained linked to the exigencies of verisimilitude. In both paintings he again employs a cropped magnification of the figures closest to the picture plane, constructing the narrative in relation to their dominant positions. This is especially evident in *Cocktail Lounge*, where the herringbone pattern of a man's jacket, seen from behind, commands one-third of the picture.

Layered space—a foreground of overscaled, animated figures, a compressed middle ground, and a distant, more abstracted background—are common to Park's work of these years. In two small paintings, *Tournament* (c. 1953; Pl. 10) and *Audience* (c. 1953; Pl. 11), Park seems intent on extending the dimensional limits of each situation to its maximum. In the small, vertical golf painting, Park dramatically compresses the course by painting three tiers of players: a front row of light-bathed men, a middle group, mostly painted

black, and a set of stick figures and red tee flag on the far horizon. In *Audience* he audaciously piled in nearly thirty people, all seen from the back except the two distant, onstage performers. *Audience* is the most condensed of Park's attempts at replicating the eye's ability to see peripherally and almost panoramically, while simultaneously focusing on a single event or object.

Park's portrayal of social animation reaches its apogee in the Fauvist-colored *Sophomore Society* (c. 1953; Pl. 12), inspired by the jazz band's gigs. The stripes and patterns of such earlier paintings as *The Beach Ball* and *Cocktail Lounge* are jumbled together here with impressive bravado. Four couples dance across a tan and oxblood checkered floor (which Park implausibly extends into the far corners of the room). The wall behind them is broadly striped in pink and brown. The darker foreground couple is highlighted in red. Behind them a chartreuse and red striped jacket enlivens the woman of the second pair. The blazing red dress of the third, centrally positioned woman makes for a swirling vertical amid the cacophony of patterns, stripes, and bright color. By now Park's confidence in his compositional skills, as well as his palette, are such that neither anatomical, spatial, nor architectural verisimilitude interest him.

A large and unique collage from the same moment, *Four in the Afternoon* (1953; Pl. 13), is further evidence of his insistent search for a densely packed yet panoramic space. This assembly of cutout people, some single, others in clusters, may have been intended for some advertising purpose—perhaps to publicize a class or event at the university since the dominant head in the foreground is that of Park's friend Stephen Pepper, chairman of the Berkeley art department. In a less resolved way than in *Sophomore Society*, the collage shows Park composing on a grand scale with a mass of figures in an ambiguous, shifting space—partly outdoors, partly not.

In smaller portraits from this period, Park used the likenesses of friends and that of Lydia to experiment with varying paint applications, amplifying their effects with charged or subdued color. Flat, unmodulated fields isolate the monumental busts *Portrait of PGD* (c. 1952; Pl. 16) and *Head of Lydia* (c. 1953; Pl. 18). Presented frontally, and with an uncharacteristically severe look, each woman seems as two-dimensional as the plane of color that surrounds her. In contrast to these thinly painted, dry portraits are others such as *Portrait of Lydia Park* (1953; Pl. 20) and *Portrait of Richard Diebenkorn*

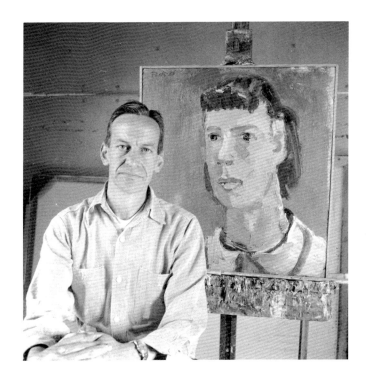

(1955; Pl. 17). In each, thick slabs of paint build the subject's features, and the heads are turned as if to demonstrate their three-dimensional physicality.

The Diebenkorns had reentered the Parks' lives at the end of the summer of 1953 when they returned to Berkeley. After his resignation from CSFA, Elmer Bischoff had moved to a small town north of San Francisco. He and Park had kept in touch, sharing studio visits and ideas about figuration, as Bischoff too moved away from abstraction after leaving San Francisco. With Diebenkorn's reappearance, the three resumed a dialogue they had begun in the late 1940s. In their reciprocal visits, Diebenkorn, who continued to work in a gestural abstract manner, challenged Park to defend his return to representationalism.

A one-artist show of Park's narrative scenes and portraits at the King Ubu Gallery in August 1953 allowed him, as well as the San Francisco art community, to survey the progress of his new style. An artist-run gallery, directed by the painter and collagist Jess and the poet Robert Duncan, King Ubu's program was geared to younger San Francisco artists; it was a mark of Park's new status as a maverick that

he would even be invited to show there. His new paintings became increasingly influential on other artists' reactions against the gestural style by now codified in San Francisco as well as New York.

After the King Ubu show, Park abandoned his anecdotal strain of working in favor of more ambitious, psychologically charged conceptions, often involving couples or groups. In these works, intimacy and its absence are the underlying themes. One of the first and the largest of them is the brightly colored *Boston Street Scene* (1954; Pl. 24). Despite its searing red background—the bricks of Back Bay—this is a cold work that addresses the state of isolation, even alienation. In a credible spatial contruction, a buff-colored expanse of street divides the figures. By rendering the young men in two different styles—those at rear as two-dimensional stick figures, the boy in the foreground more detailed and physically plausible—Park successfully captures distinct nuances of character. With thick strokes of white paint for a light fixture and for the clothes of two figures not yet engulfed in the creeping twilight, Park also evokes a poignant atmosphere. Like many of its successors, *Boston Street Scene* turns the clear, bright light of San Francisco on the urban geometry of a remembered Boston. In this painting, Park masterfully demonstrates the effects of abstraction on his unquestionably figurative vision.

Because Park was earning little income from his work—a 1954 one-artist show at the prestigious Paul Kantor Gallery in Los Angeles produced no sales—he was occasionally obliged to accept portrait commissions. The most flamboyant portrait of this moment is *Woman with Red Mouth* (1954; Pl. 25), an unfinished painting of the art patron Ellen Bransten. Because this painting was abandoned at an early stage—it is more a drawing in paint—it provides an interesting testimony to Park's working methods. As no preparatory drawings exist, it seems Park's composition is completely improvisatory. A half-length woman is depicted, her raised left hand holding a lit cigarette between the fingers. Her facial features are dominated by two bright red lips smeared across the mouth. Dabs of red nail polish complement the woman's lips in this otherwise black and cream-colored picture. Mrs. Bransten disliked the portrayal, and Park never completed or exhibited it. According to Diebenkorn, the artist thought the likeness "cruel."[21]

The strident reds of both *Boston Street Scene* and *Woman with Red Mouth* mark the rapid evolution of Park's understanding of color in

relationship to form. During 1954 and 1955 he used color more and more to supersede the constraints of representationalism. In such paintings as *Flower Market* (1955; Pl. 27), he extends the liberating colors of *Sophomore Society* to more decidedly Fauvist ends. The ambient color of the far bank of abstract marks (presumably flowers) also appears implausibly in the customer's face. This overriding optical, rather than physical, color is a signal of Park's increasing use of the figure as a purely formal vehicle rather than as a narrative symbol.

A series of small still lifes, done in the summer of 1956, form a coda to Park's illusionist works. Inspired by Manet, Diebenkorn had begun in 1955 to paint some of the things around his studio—experiments in still life that were the earliest signs of his impending reversion to figurative painting. Park attempted something comparable in such paintings as *Brush and Comb* and *Sink*, both of 1956 (Pls. 30, 31). Unlike Diebenkorn's more traditional method of working in front of his subject, Park, as always, preferred to rely on visual memory. The pictures, despite their small size, are lush and amazingly evocative representations—each achieved with but a few economic gestures. They constitute a purification of Park's heretofore staccato painting methods, as Elmer Bischoff seems to have understood. Speaking of this series, he said: "The interrelation of these things falls on the color and the light and the volume, not on the contour. Where I like David's things most is where I feel their coherence was through painterly means and not through the locking together of patterns."[22]

In life drawing sessions that initially included Diebenkorn and Bischoff and later James Weeks, Paul Wonner and others, Park honed his already acute skills as a direct and telling draftsman. Certain of the representational abbreviations of the 1956 still lifes began to appear in such large paintings as *Standing Male Nude in the Shower* (1957; Pl. 33) and *Bather with Knee Up* (1957; Pl. 34). These new monumental, single subjects, with their eloquent postures, permitted Park to emphasize the paint handling of both figure and ground. The odd, off-center view of a man drying his back in *Bather with Yellow Towel* (1956; Pl. 32) is typical of the increasingly stark environments—essentially gestural abstractions redolent of nature—in which his figures would be placed. The showering male nude and the male figure with his knee up are most likely derived from drawing sessions where the teenage Page Schorer, son of Park's friend Mark Schorer, was the model.

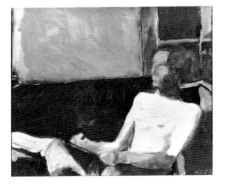

Richard Diebenkorn
David Park on a Hot Day,
1956
Oil on canvas, 13¾ × 17
inches
Private collection

If *Standing Male Nude*, with its bright red body and furious purplish face, has a troubling, almost devilish cast, the serene profile and beautiful indeterminate ground of *Bather with Knee Up* seems angelic, classical. The shower painting, while somewhat awkward in the handling of the feet, finds Park working almost at life-size for the first time. The smaller but more compelling *Bather with Knee Up* profits not only from a wide range of tonal contrasts and more fluent overall paint handling, but also from the abstract values of the blue-green ground. Enlivened with zigzag strokes that move up and down over a yellow sky, this painting incorporates a horizon line for the first time in Park's work. By using a single monumental figure and situating it in a richly ambiguous habitat suggestive of nature, Park completed his move from ordinary and locatable subjects to figurative symbols that can allude to universal human conditions.

The painterly atmosphere of *Three Women* (1957; Pl. 35) further elaborates the gestural grounds of *Bather with Yellow Towel* and *Bather with Knee Up*. The women are rendered with more abandon than anything in Park's previous work. Ironically, it seems as if the gestural freedom inherent to Abstract Expressionism remained beyond his reach so long as he painted non-objectively. Eight years into his figurative style, Park had finally gained sufficient faith in the representational powers of his imagery to begin incorporating gestural abstraction as an almost equal force in his work. In *Three Women*, all three figures exist in an atmosphere of agitated paint marks. Two dark blobs define the eyes of the figure at lower right, an inverted L suffices for the nose, and a red circle drops from it to compose her mouth. In an otherwise dark-green and flesh-colored picture, this red mark makes her mouth a key element. Yet because the two other figures turn their backs to her, the effect is one of silence. Alone, but in a group, their isolation makes the painting seem tragic.

The tension and interplay between abstract field and representational subjects that distinguish Park's work of this period contribute to a gradual dislocation of figures from the physical world. This is particularly evident in the series of canoe paintings he did during 1957. *Canoe* (Pl. 37), for example, features a couple paddling to the front of the painting. The canoe is located on a watery green expanse, which occupies most of the canvas. By filling it with powerful calligraphic strokes, Park renders an indeterminate physical locale, hence, an arena for the purely abstract. This same will to

abstraction characterizes the faces: two short, parallel red lines distinguish the female in the bow; her male companion sports a black dot mouth and only one dot for a right eye. With this single dot, a new freedom in the rendering of facial features enters Park's work.

In the related *Green Canoe* (Pl. 36), Park allows himself even more descriptive freedom in painting the water, where a fretwork of burnt sienna strokes marks the canoe's progress. In both paintings a distant horizon of equally ferocious marks—roughly vertical and airy in *Green Canoe*, densely stacked and horizontal in *Canoe*—permits Park to juxtapose another set of abstract, more linear marks (symbolic of distant nature) against his calligraphic variations for water. These and other boating paintings, such as *Rowboat* (1958; Pl. 48) were most likely based on childhood recollections of Peterborough or the family home in West Boxford.

Some of the new gestural bravado of these outdoor paintings found its way into Park's interiors. One of the largest of them, *Interior* (1957; Pl. 38), reveals his confidence in simply inferring architectural space. A mix of white and magenta-brown paint establishes a moody light in this scene, which combines a seated Elmer Bischoff sketching and Lydia lying down. While the Bischoff figure is cursorily defined by a few black lines, Lydia is tenderly described. The three defining planes of the room are treated as atmospheric expositions of Park's gestural powers. Park situates three partially seen windows as a clerestory in this studio scenario, recalling the high horizons of the Canoe series. Similarly, these framed glimpses of nature have been reduced to patches of blue and a few sticklike lines. His earlier experiments with receding space (most similarly in the table of *Table with Fruit*) are recalled as well by Lydia's striped cot. Although figures and objects conform to gravity, they seem to sit together in a common space purely through the synthesis of the painter's strokes. His touch knits things together, harmonizing impossible blocks of color and the substantial differences in tone and implied scale between man and woman. *Interior* was based on studies (Pl. 70) made in Park's final life-drawing sessions with Diebenkorn and Bischoff. It is one of the last of his large-scale paintings to employ either architectural space or the recognizable images of those around him.

A comparable intimist theme, and one Park had addressed before in *Table with Fruit* (and even earlier in *Four People Drinking a Toast*)

was the social ritual of eating and drinking that animates *The Table* (1957; Pl. 39). Park's longtime fascination with white reaches its fullest expression here in the white tablecloth on which two couples share a meal. Using a restricted palette of white, red, black, brown, and blue, Park seems to have been concerned with distinguishing the white shirt that fills the right bottom quadrant of the canvas from the adjoining white of the cloth and with capturing the translucency of the blue-painted glasses against the tablecloth. The specificity of the figures of *Interior* and *The Table* is related to Park's final forays into portraiture—small works intended as gifts to friends. The hazy, pastel light of *Interior* is akin to the orange glow that humorously salutes the auburn-haired subject of *Portrait of Mrs. C.* (1958; Pl. 47), while the white glare of *The Table* has a counterpoint in the stark, forcefully rendered *Portrait of Mark Schorer* (1955–57; Pl. 29). Just as these would be his last portraits, *Interior* and *The Table* would be Park's final genre paintings: henceforth, he would employ only gestural renditions of figures as he infused abstract values into every part of his imagery.

Yet his imagery remained figurative and his technique radically anomalous even within the community of empathetic painters such as Diebenkorn and Bischoff. When Diebenkorn began painting figuratively again in 1956, he employed a broad, brushy technique that monumentalized the architectural space around his figures no less than the figures themselves; Bischoff's work subjected both figure and ground to highly evocative saturated color treatments indebted to Impressionism and Post-Impressionism.

Nude—Green (1957; Pl. 40), the culmination of Park's many sessions with models, declares the equality of abstract ground and gestural figure more decisively than do the paintings of Diebenkorn and Bischoff. With the painting's crudely composed female, unfinished, verdant green field, and spatially illogical yellow band at bottom, Park gives up the fiction of pictorial space, concentrating instead on the process of painting.

By 1957 Park's new work had attracted considerable attention and has subsequently been cited as a forerunner to a school of figurative artists at work in San Francisco.[23] In the summer of 1955 he had been appointed assistant professor of art at the University of California,

Berkeley, providing him with a steady income and renewed contact with students. As a figurative artist, he was in a distinct minority among Berkeley's gestural abstractionists, but he was an unabashed proselytizer in his classes, insisting that everyone work from a model. At home, his paintings benefited from a large, light-filled studio in the former attic of the home Park and his wife bought in 1956.

That same year, Paul Mills, the new director of The Oakland Museum, began organizing an exhibition of recent work by Bay Area artists who used figurative subject matter. Park, Diebenkorn, Bischoff, and Weeks were obvious choices for the show, which included work by eight other painters as well.[24] "Contemporary Bay Area Figurative Painting" opened in Oakland in September 1957, then traveled to Los Angeles and Dayton, Ohio. Park exhibited *Interior*, among other paintings, mostly to a positive critical response.

In the catalogue, Park spoke of the change in his work after 1949: "I saw that if I would accept subjects, I could paint with more absorption, with a certain enthusiasm for the subject which would allow some of the aesthetic qualities, such as color and composition, to evolve more naturally. With subjects, the difference is that I feel a natural development of the painting rather than a formal, self-conscious one." He went on to see only a slim distinction between abstraction and figurative painting, at least as he practiced it: "the line between non-objective painting and figurative painting is no different than the line between still life and portrait painting."[25]

Park's reexamination of the figure in his Berkeley classes encouraged him to reconsider and vary the interaction of his representational and abstract motifs. Two of the best paintings of 1958, *Man in a T-Shirt* (Pl. 43) and *Red Bather* (Pl. 44) exemplify two different responses. The seated figure in a T-shirt is treated in a broad fashion, a composite of big strokes defined by darker silhouettes. A bulky form, with quirky, bright red ears, he coexists with the dark, two-part ground. By contrast, in *Red Bather* the dramatically painted ground nearly overpowers the thin, fragile-looking, solitary beachgoer.

Four Men (1958; Pl. 45), the largest and most haunting of his late paintings, reprises the boating theme. It shows Park in full control both of his beloved figures and a kind of painterly bravado usually associated with abstract art. Although four figures appear, they share the sense of psychological isolation found in Park's earlier works. By rendering each man's face and body with a different degree of reality, he separates them into distinct types. The most completely realized

figure is left of center, while the standing man next to him is almost sticklike. The cropped proximity and large size of the figure at lower right make him the most eccentric in the group, with his sad face emphatically rendered in red and blue marks. He is almost a contemporary Pierrot—comical, but alone. The fourth man, in the boat at left, turns his back to the group and to us. On the giant expanse of water (the painting is about 5 × 8 feet) Park set down a range of evocative strokes. The agitated water around the boat gives way to a horizon-water passage at the upper right that seems a response to Hans Hofmann's "slab" compositions of roughly the same moment.

The somewhat smaller and more abstractly rendered paintings that followed, such as *Two Bathers* and *Women in a Landscape* (both 1958; Pls. 49, 51), are also notable for lush paint handling. In the overlapping convergence of an upraised white towel and the white sky of *Two Bathers*, Park explores the qualities of evanescent light and space particular to that color. The darker colors that describe the figures make the contrasting lights especially apparent, while isolating and thus emphasizing the viscous, thickly worked skin of white paint. In *Women in a Landscape* he locates two monumental, roughly drawn women in his most gestural setting to date. The right third of this painting would be a noteworthy and convincing abstract work on its own. It is eloquent testimony to Park's elated brushwork, comparable to that of any of the nonrepresentational gesture painters of the day.

Both the issue of light and the independence of gesture animate the *summa* of Park's large group paintings, *Four Women* (1959; Pl. 55). The subjects are Park at his most assertively massive. Flooded with sepulchral white light, each woman of the quartet is presented almost as a marble or alabaster bas-relief. The furious red ground around them reinforces the picture's disturbing, nighttime glow. By reducing his palette to black, white, and red, Park underscores the primacy of his strokes—alternately carving out a bulky space for the corpulent figures or elaborating an agitated flat field in which to stand them. Eerie in its pronounced chiaroscuro, *Four Women* is a last consideration of the narrative inherent in the depiction of a loosely configured group: the story here is one of loneliness, disenchantment, and profound isolation.

In three smaller single-figure pictures of 1959, *Boy with Red Collar*, *Boy's Head*, and *Figure* (Pls. 52, 53, 58), Park returns to his old fascination with portrait busts, but to radically different ends. In

all three, he is far from the concerns of likeness. The rapid execution—his strokes are broad and so few that it is almost possible to count them in each painting—seems to have been an end in itself. This seemingly improvisatory and highly economic manner of drawing in paint yields great visual drama. Park lavishes even more paint than usual on these smaller works. *Boy's Head* presents a relatively clear separation of figure and ground: a tan and red face stands out from the brushy blue and red ground. *Boy with Red Collar* and *Figure* obey no such conventions. Here Park's intense painting motion creates a spatially and physically undifferentiated layer of pigment that unites figure and ground. With these small pictures, Park seems almost ready to unleash his painting from any representational goals. It would appear as if he were veering from his style of the past decade toward one that would conform to Abstract Expressionism's central faith in the revelatory power of the non-objective mark.

But Park would never completely adopt abstraction. In *Beach Ball* (1959; Pl. 62), one of the large late paintings that reconnect him to his figurative origins, two figures scramble, arms overhead, for a flying ball. The cold light of *Four Women* is replaced here by a hot red hue. The diagonal orientation of the figures, combined with the painting's long, jagged vertical strokes, suggests Park's attempt to get beyond the static compositional order of *Four Women* as he searched for other formats that could be as charged as his brushwork.

Park's two final large-scale paintings, *Daphne* and *The Cellist* (Pls. 63, 64), reveal comparably novel treatments. In *Daphne*, Park isolates a single, monumental woman but chooses a vulnerable pose for her. One arm stretched above her head, she is an overscaled figure in an uncompromisingly gestural, abstract ground decorated with eccentric, calligraphic marks that seem to contradict gravity. It is an uneasy cohabitation, the figure disturbingly large in relation to the size of the canvas. This disjunction is no more gracefully resolved in *The Cellist*. The seated player and her giant instrument overwhelm—practically fall out of—the picture. Like *Daphne*, the musician is accomplished with a few broadly rendered areas of strokes. Park's figures at this point have outgrown the scale and ambience of his canvases. Their thick, gigantic bodies are posed frontally, hinting at some mythic personae.

Where these disturbing, overscaled figures would have led must remain conjectural. Bothered by back trouble since his wartime accident at General Cable, Park entered the hospital in November

1959 for a disc operation. As he recuperated, his wife and daughter brought him art supplies to wile away time, including a roll of ordinary shelf paper. Park began drawing on the toothy paper with colored markers, almost doodling. Soon he had begun one of his street scene narratives, replete with the architecture and slightly comical characters of some of his more anecdotal paintings. The "story" he told (as the shelf paper was gradually unrolled across a tray across the hospital bed) was a mélange of familiar-looking figures—a hatted woman, people seated at a table, a man in a T-shirt, people in a boat—that animated a long stretch of some imaginary small town, possibly Back Bay, Boston (Pl. 79). Confined to the bed, Park returned to childhood memories and fantasies. The result is charming and pictorially sophisticated. It also ends on an ominous note: the final stretch is a deserted purplish street with a clock showing the time at 4 (a quotation from his 1954 collage *Four in the Afternoon*?), a street sign marked "Dead End" above, and a skull and crossbones below.

After Park went home in early winter his health deteriorated further. By May his "back problem" had been diagnosed after a second operation as terminal cancer. Physically unable to climb stairs or to stand up to paint, he turned to gouache as a fast-drying medium that could technically replicate his favored oil paint. He set about producing what he knew would be his final works. In the following ten weeks, he completed about one hundred gouache drawings, working for short periods of time atop a bedside table in a lounge chair. Park signed about ninety of them, but destroyed others. Longtime Park themes—musicians, mothers and children, men and women in interesting postures and acts—supplied the weakening Park with motifs. In such works as *Man Playing Violin* and *Seated Figure* (Pls. 75, 76), Park's mastery of the most intense palette imaginable and his deft drawing skills are obvious. By July 1960, however, he was unable to work; David Park died at home on September 20.

Park's late paintings were featured in a show at the Staempfli Gallery in New York in 1961 and received somewhat mixed reviews.[26] The long reign of Abstract Expressionism was ending, but its successor had not yet been established; some second-generation Abstract Expressionists, largely taking their lead from de Kooning, sought to

introduce figures into their otherwise gestural work. Others were developing a nonrepresentational gestural mode, Color Field abstraction, that quickly attracted an important critical following.

In San Francisco around 1960, Bay Area Figuration was degenerating into diverse academic styles united only by a common use of impasto and gesturalism. The younger painter Joan Brown seemed to be the sole heir to Bay Area Figuration as it had been defined by Park, Bischoff, and Diebenkorn in the mid-1950s. (Bischoff and Diebenkorn returned to abstract styles in 1965 and 1967, respectively.)

By the time of Park's 1961 retrospective at the Staempfli Gallery, New York was more than ready to reconsider representational art, but it was another kind of figuration, soon to be dubbed "Pop," that won out over the figurative expressionism practiced by Park and the San Francisco painters. Although Diebenkorn's work attracted favorable attention at regular New York shows throughout the 1960s (especially after his return to abstraction), Park's place in the critical consciousness faded; eventually his work became a symbol of regional reactionism, available for sporadic and fragmentary revivals.

Nor has the wholesale resurrection of expressionist figuration in the 1980s done much to salvage Park's fortunes. Eastern bias against West Coast artists, the relatively small body of mature works, and Park's own modesty about his achievements may be responsible for this benign neglect. The problem had been put differently by Sidney Tillim in 1962: "In Park's dogged climb to some measure of competence and sophistication, I found recapitulated virtually all the problems that have plagued the American artist since the Mayflower."[27] Although Tillim's remark poignantly describes the first two-thirds of Park's career, it implicitly slights the accomplishments of his last decade. In this period, Park's achievements far surpassed "some measure of competence and sophistication." Indeed, his pioneering efforts had led him into uncharted territory, which seems as bountiful today as it did forty years ago.

PAINTINGS

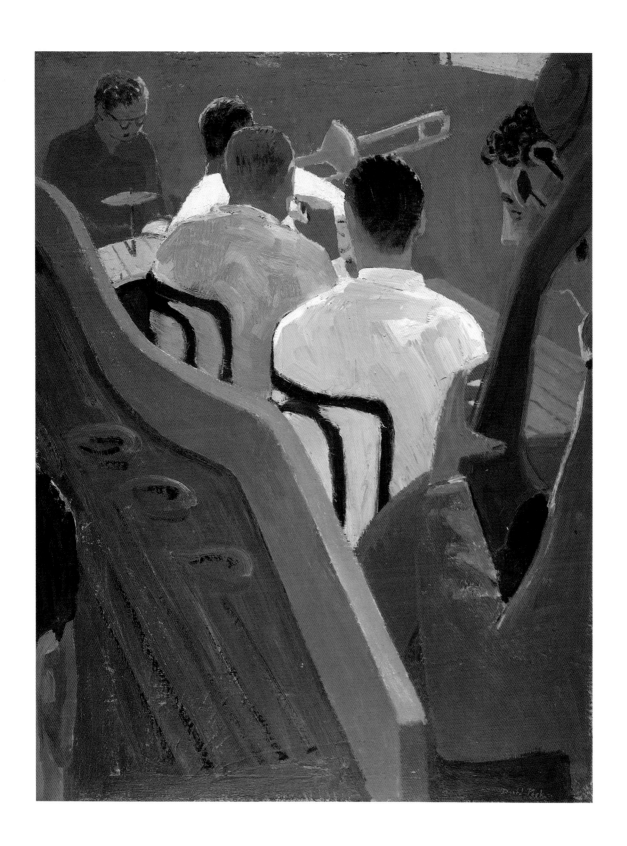

1.

Rehearsal, 1949–50

Oil on canvas, 46 × 35¾ inches

The Oakland Museum, California; Gift of the Anonymous

Donor Program of the American Federation of Arts

49

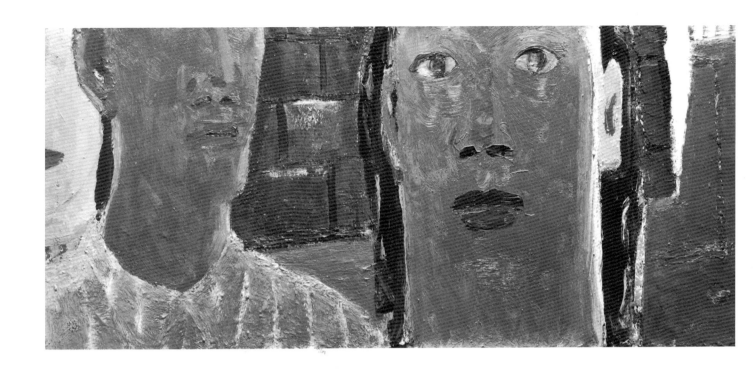

2.

Untitled, 1950
Oil on canvas, 18 × 40 inches
Collection of Suki Schorer

3.
The Beach Ball, 1950
Oil on canvas, 36 × 24 inches
Private collection

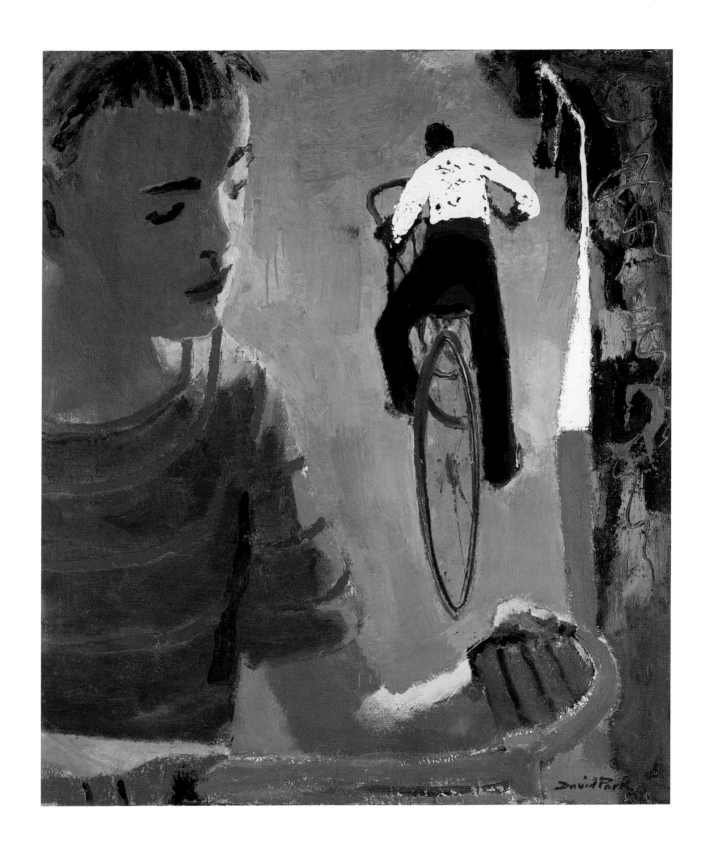

4.

Kids on Bikes, 1950
Oil on canvas, 48 × 42 inches
The Regis Collection, Minneapolis

5.

Portrait of Hassel Smith, 1951

Oil on canvas, 34 × 28 inches

Collection of Mr. and Mrs. Wilfred P. Cohen

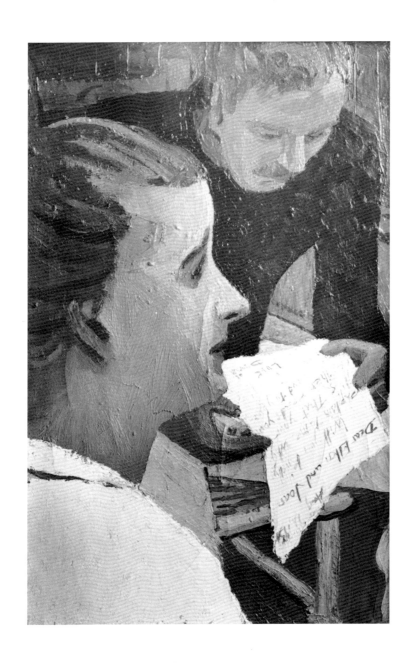

6.

The Letter, 1951

Oil on canvas, 30¾ × 20 inches

Collection of Joan and Donald Fry

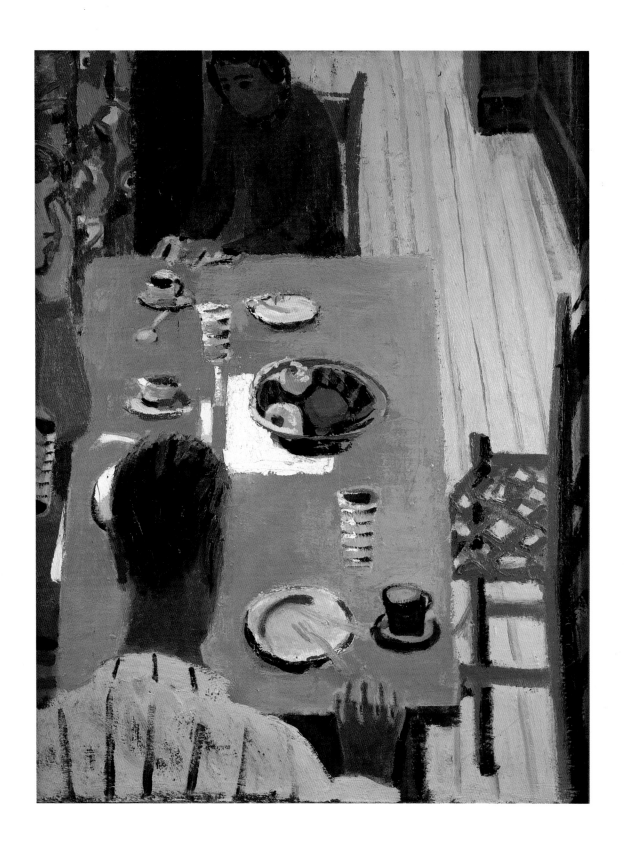

7.

Table with Fruit, 1951–52

Oil on canvas, 46 × 35¾ inches

Collection of Dorry Gates

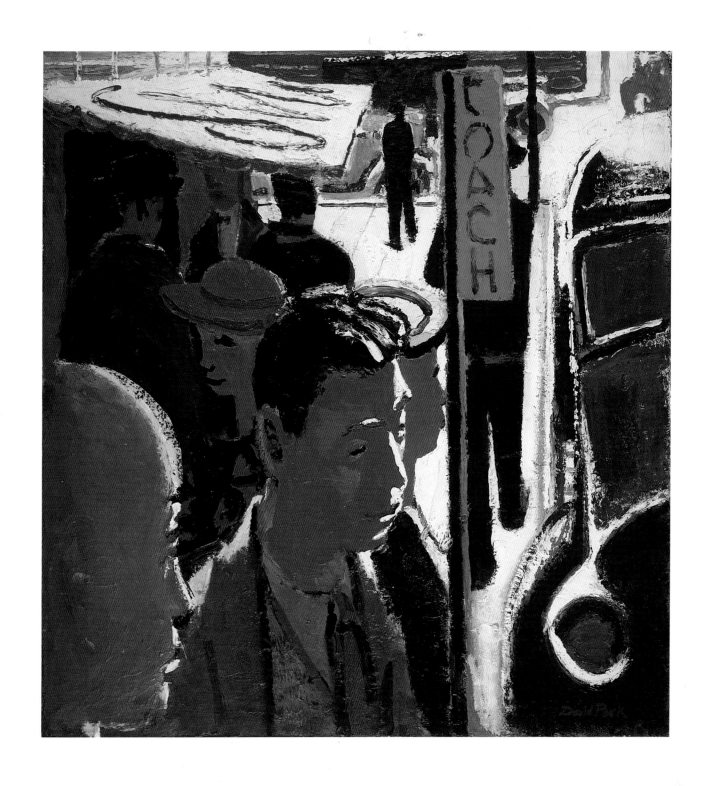

8.

Bus Stop, 1952

Oil on canvas, 36 × 34 inches

Collection of Mr. and Mrs. James R. Patton, Jr.

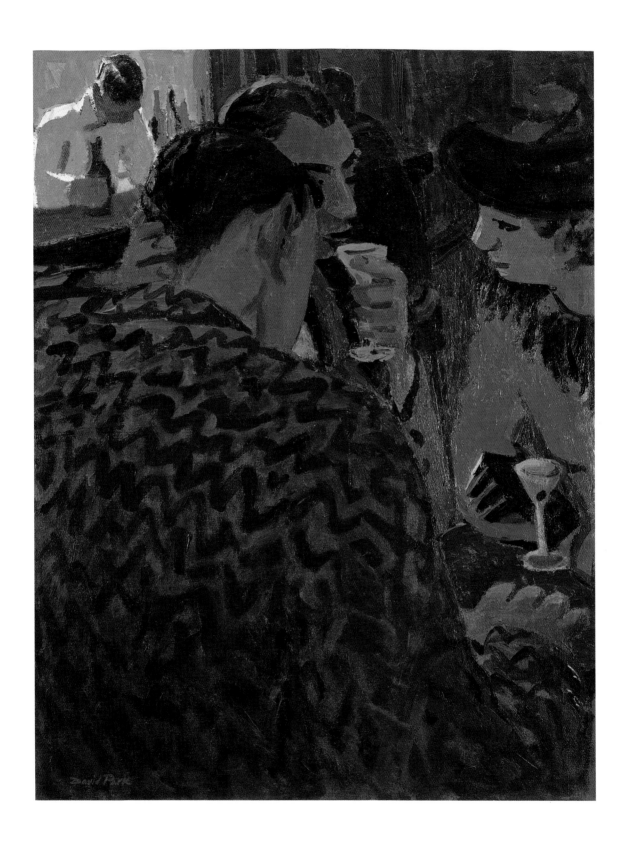

9.

Cocktail Lounge, 1952

Oil on canvas, 50 × 40 inches

Collection of Harry Cohn

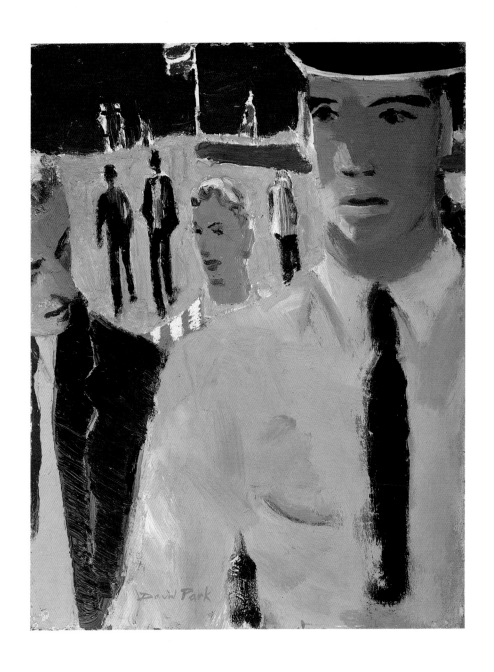

10.

Tournament, c. 1953
Oil on canvas, 18 × 13¾ inches
The Oakland Museum, California; Gift of Mrs. Roy Moore

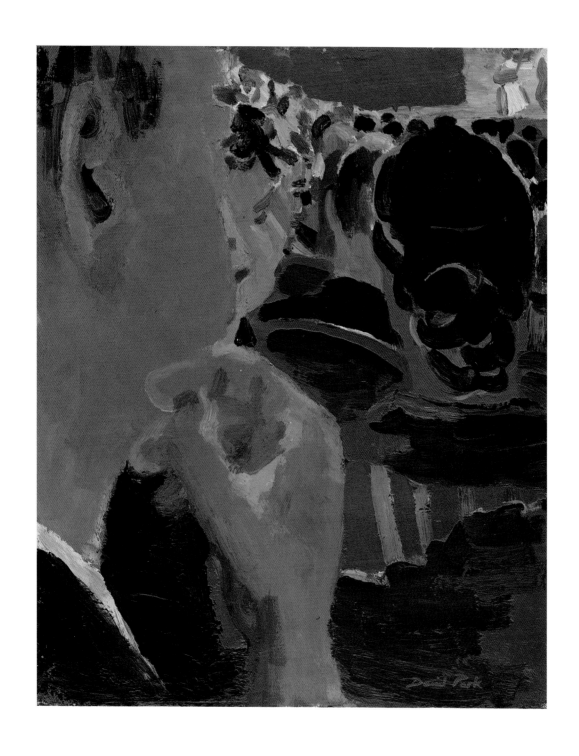

11.

Audience, c. 1953

Oil on canvas, 20 × 16 inches

The Oakland Museum, California; Gift of Mrs. Roy Moore

12.

Sophomore Society, c. 1953
Oil on canvas, 38 × 46 inches
The Corcoran Gallery of Art, Washington, D.C.;
Gift of Lydia Park Moore

13.

Four in the Afternoon, 1953

Ink and collage on paper, 81½ × 91 inches

Stanford University Museum of Art; Gift of Dr. Oliver G. Frieseke

14.

Cousin Emily and Pet Pet, 1952
Oil on canvas, 46 × 34 inches
Salander-O'Reilly Galleries, New York

15.

Boy and Car, 1955
Oil on canvas, 18 × 24 inches
Salander-O'Reilly Galleries, New York

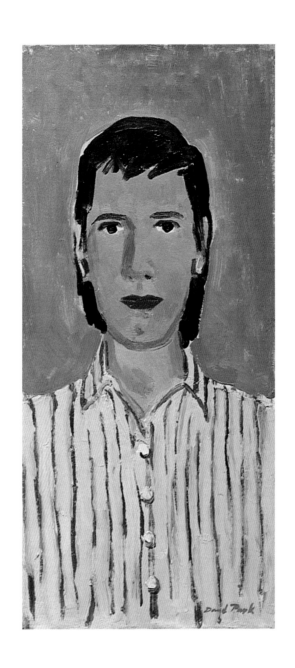

16.

Portrait of PGD, c. 1952

Oil on canvas, 22 × 10 inches

Private collection

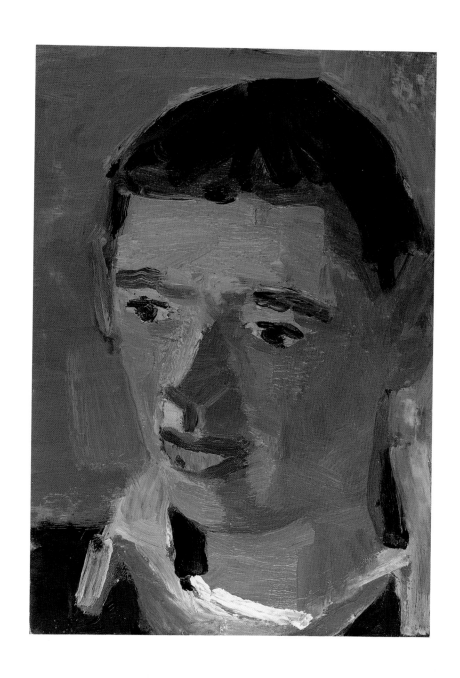

17.

Portrait of Richard Diebenkorn, 1955
Oil on canvas, 20 × 14 inches
The Oakland Museum, California; Gift of Mrs. Roy Moore

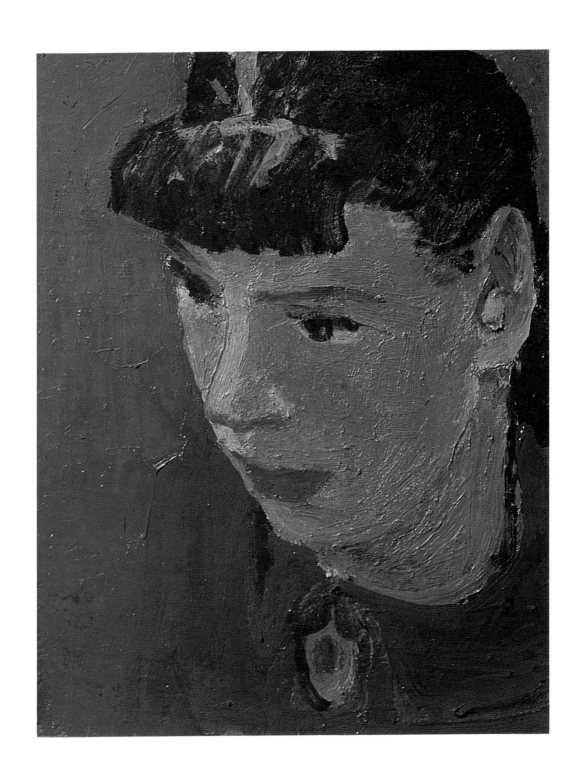

18.

Head of Lydia, c. 1953

Oil on canvas, 25 × 24½ inches

Collection of Helen Park Bigelow

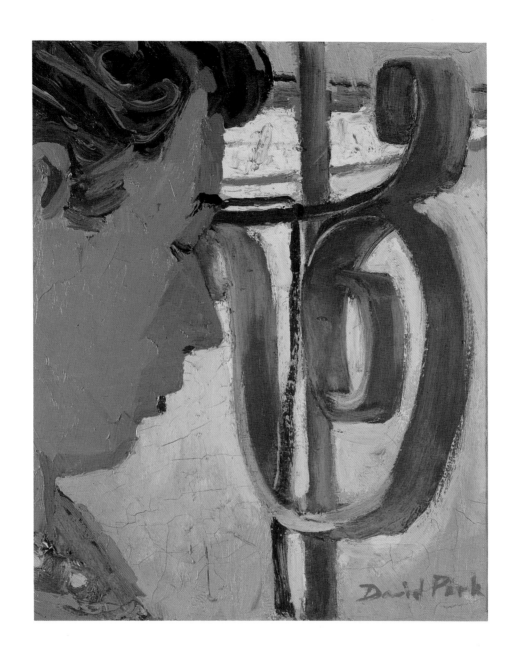

19.

Profile and Lamp, 1952

Oil on canvas, 16 × 13¾ inches

Private collection

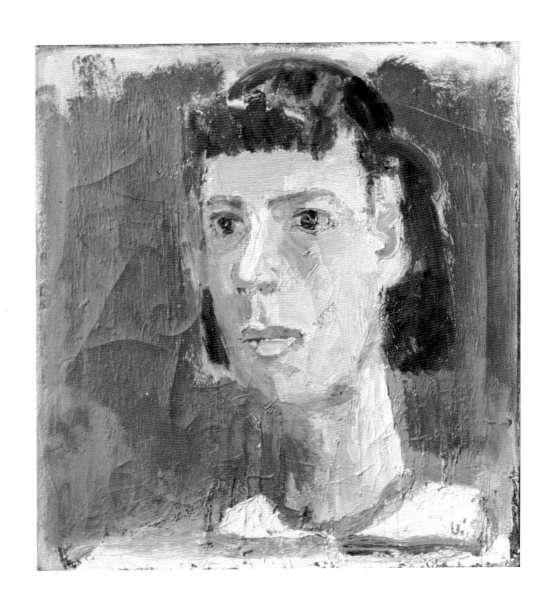

20.

Portrait of Lydia Park, 1953

Oil on canvas, 20 × 16 inches

Collection of Mr. and Mrs. Roy Moore

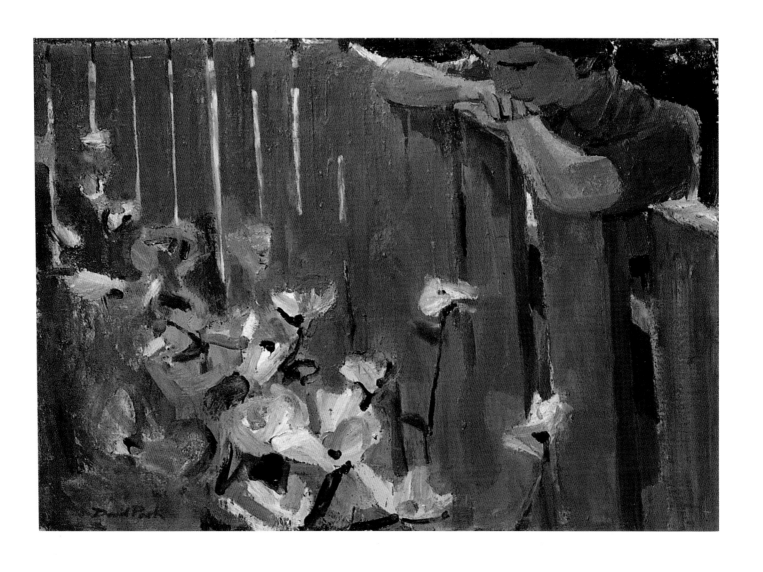

21.

Untitled, 1953

Oil on canvas, 34 × 48 inches

Collection of Mr. and Mrs. Mark S. Massel

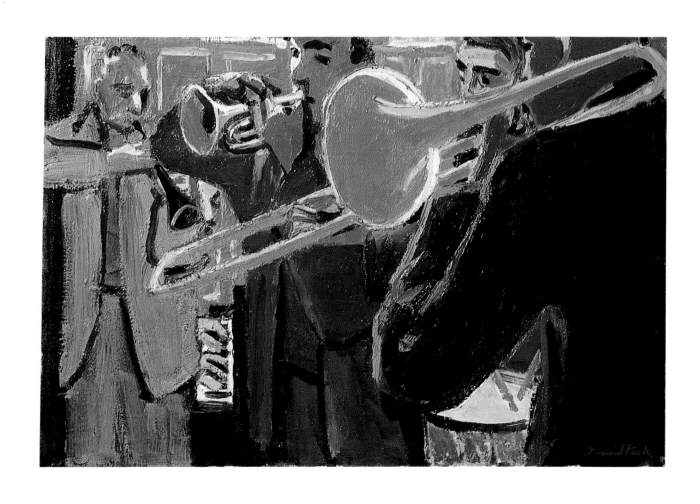

22.

Jazz Band, 1954
Oil on canvas, 24 × 36 inches
Collection of Natalie Park Schutz

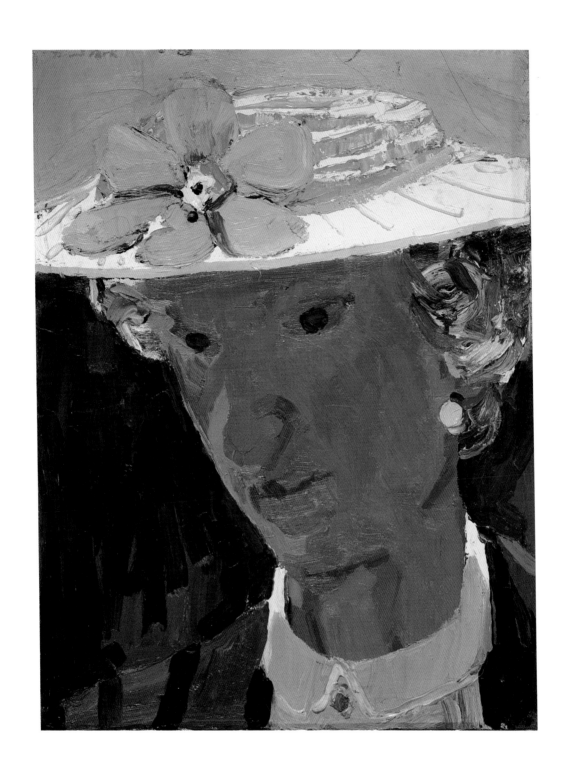

23.

Mother-in-Law, 1954–55

Oil on canvas, 26 × 19½ inches

Collection of Mr. and Mrs. Wilfred P. Cohen

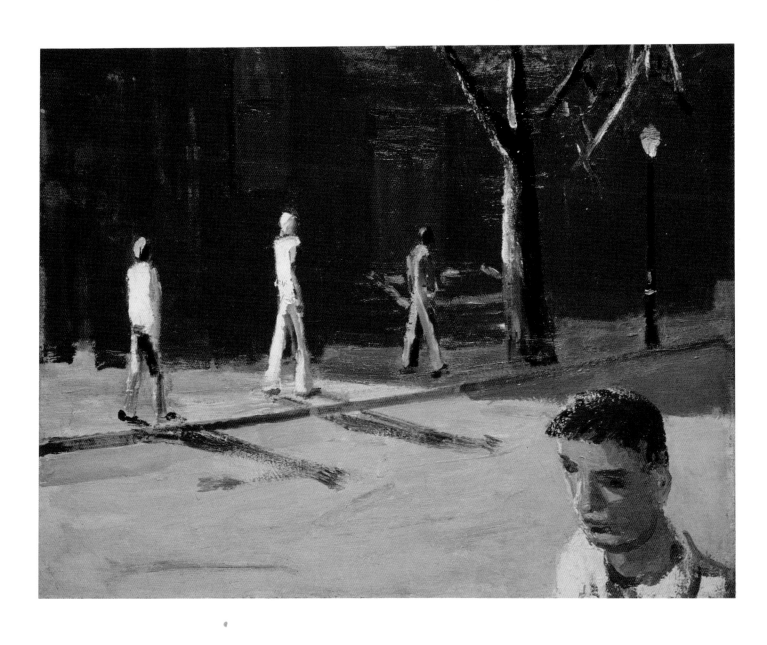

24.

Boston Street Scene, 1954

Oil on canvas, 45⅝ × 59 inches

Collection of Mr. Howard Lester

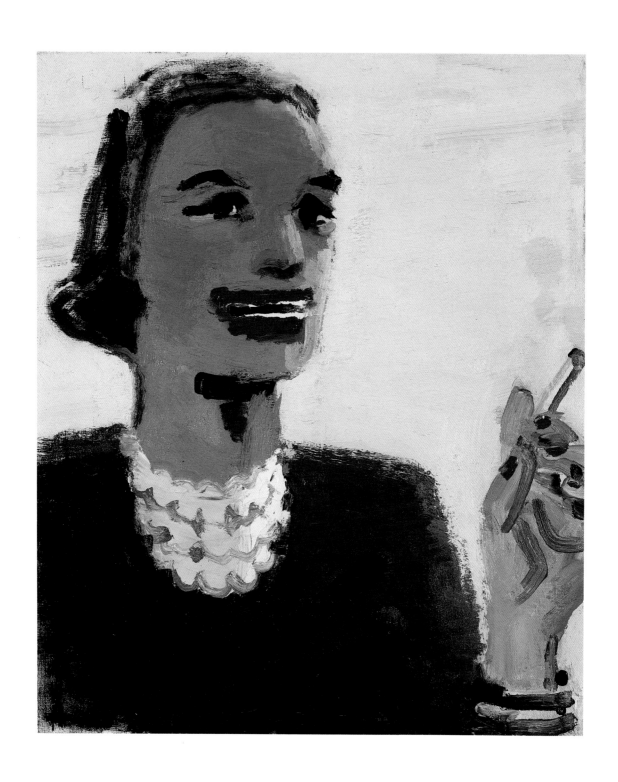

25.

Woman with Red Mouth, 1954
Oil on canvas, 28½ × 24 inches
Collection of Arthur J. Levin

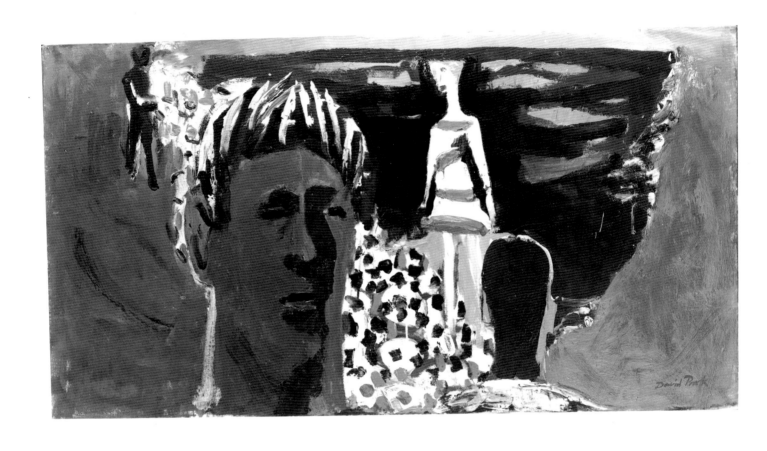

26.
Beach Scene, 1955
Oil on canvas, 26 × 50 inches
Salander-O'Reilly Galleries, New York

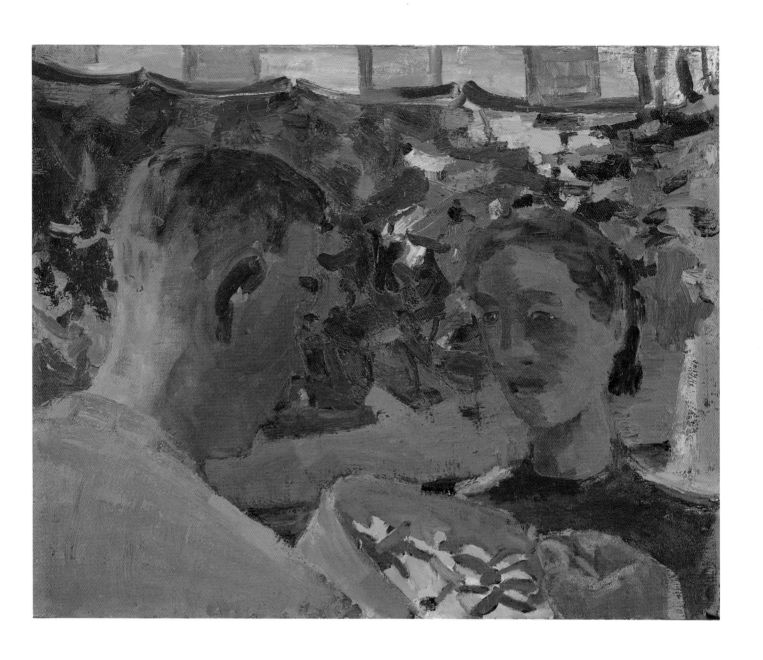

27.

Flower Market, 1955

Oil on canvas, 34½ × 43 inches

Whitney Museum of American Art, New York;

Lawrence H. Bloedel Bequest 77.1.39

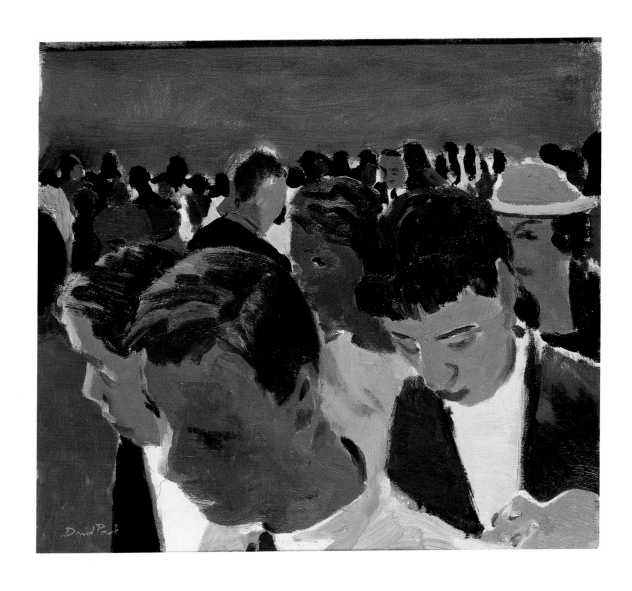

28.

Campus Scene, c. 1955
Oil on canvas, 16 × 18 inches
Collection of Joseph and Dixie Furlong

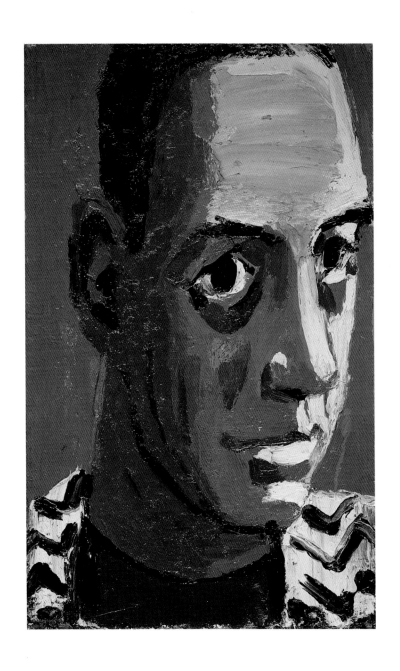

29.

Portrait of Mark Schorer, 1955–57

Oil on canvas, 16 × 10 inches

Collection of Suki Schorer

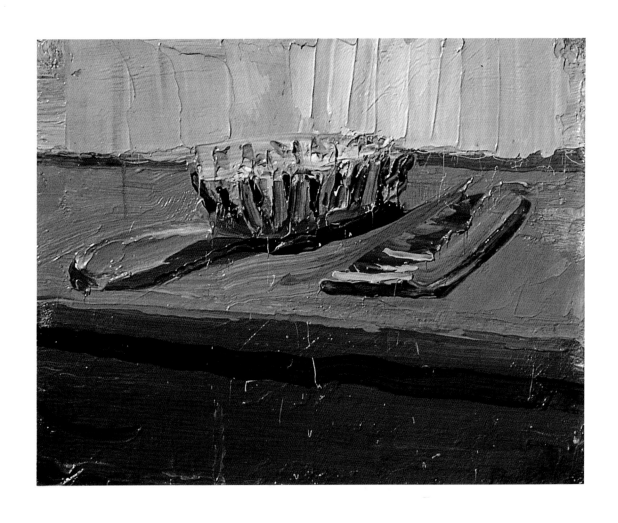

30.
Brush and Comb, 1956
Oil on canvas, 13⅞ × 17 inches
Collection of Mr. and Mrs. Roy Moore

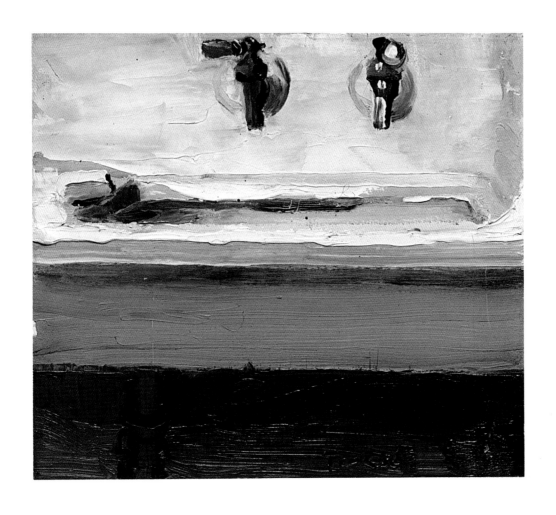

31.
Sink, 1956
Oil on canvas, 14 × 16 inches
Collection of Barbara and Jon Landau

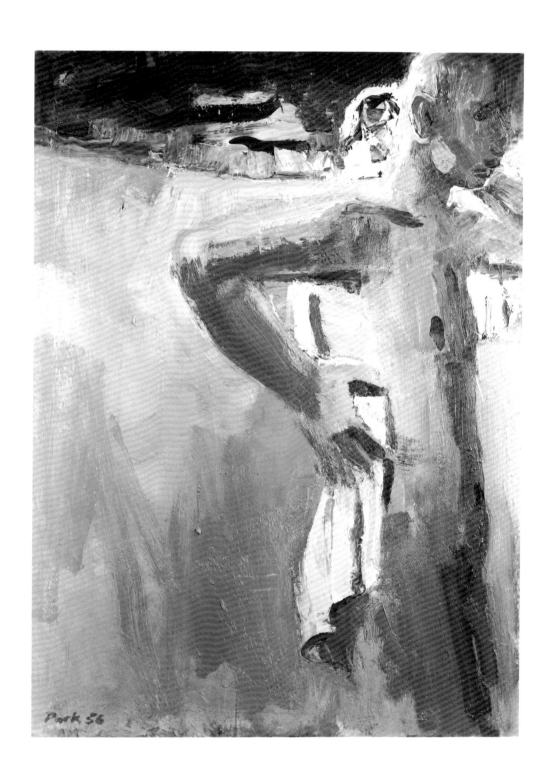

32.

Bather with Yellow Towel, 1956

Oil on canvas, 44 × 32 inches

Private collection; courtesy of John Berggruen Gallery, San Francisco

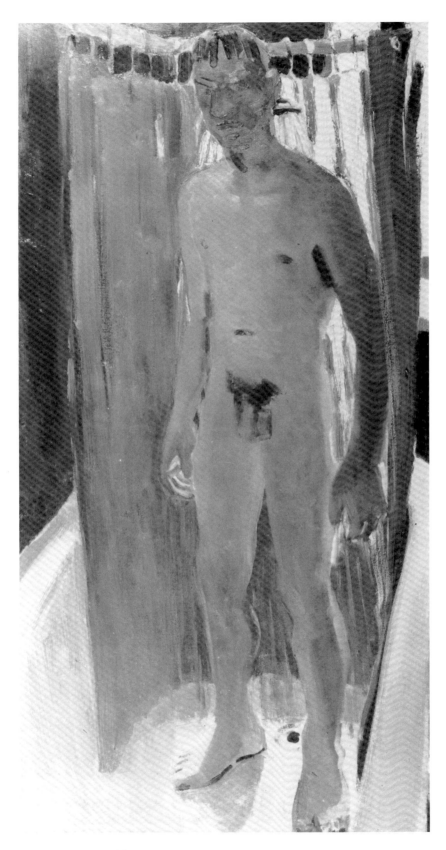

33.

Standing Male Nude in the Shower, 1957
Oil on canvas, 70¼ × 37¾ inches
Salander-O'Reilly Galleries, New York

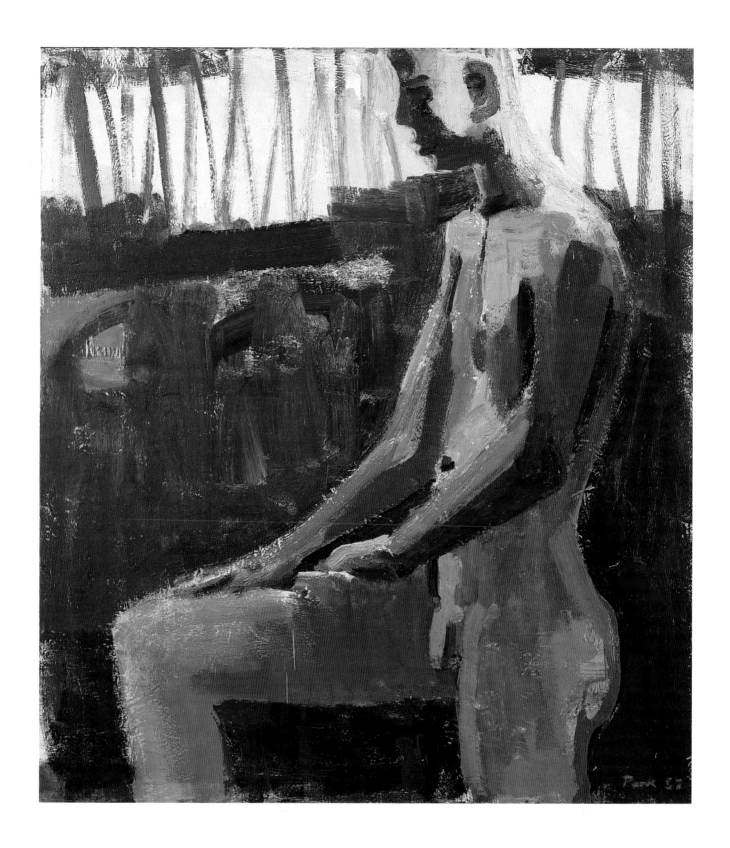

34.

Bather with Knee Up, 1957
Oil on canvas, 56 × 50 inches
Newport Harbor Art Museum, Newport Beach, California;
Gift of Mr. and Mrs. Roy Moore

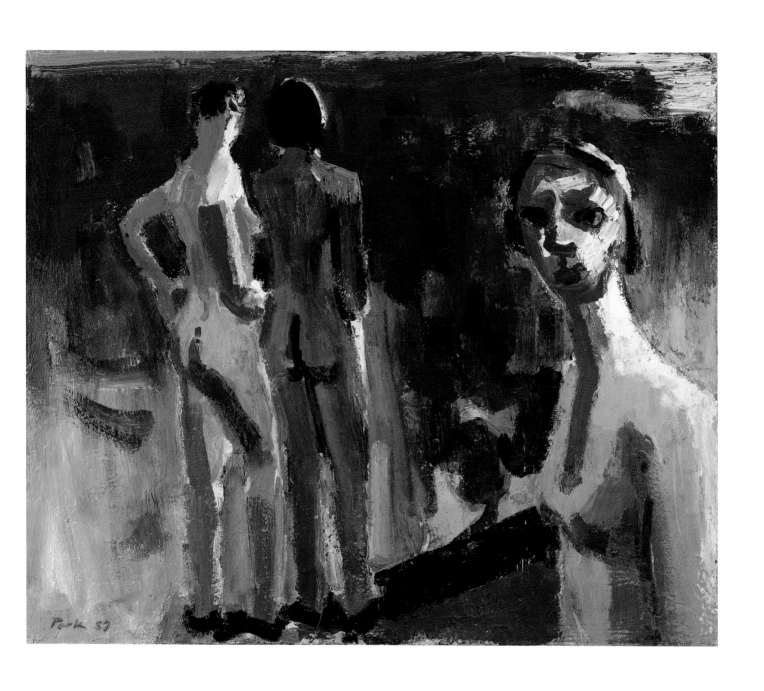

35.

Three Women, 1957

Oil on canvas, 48 × 58 inches

Santa Barbara Museum of Art; Gift of Mrs. K. W. Tremaine

in honor of Mr. Paul Mills' appointment as Director

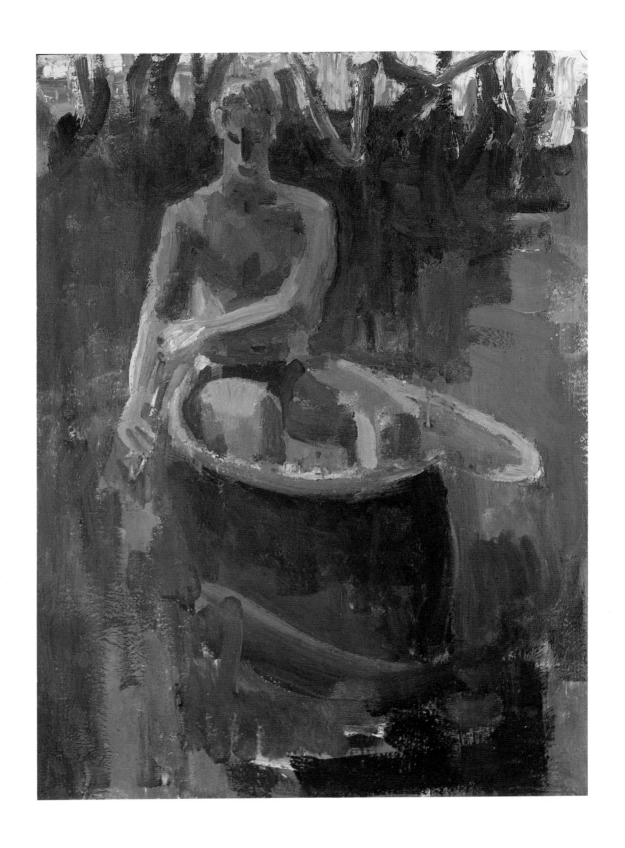

36.
Green Canoe, 1957
Oil on canvas, 52 × 40 inches
Private collection

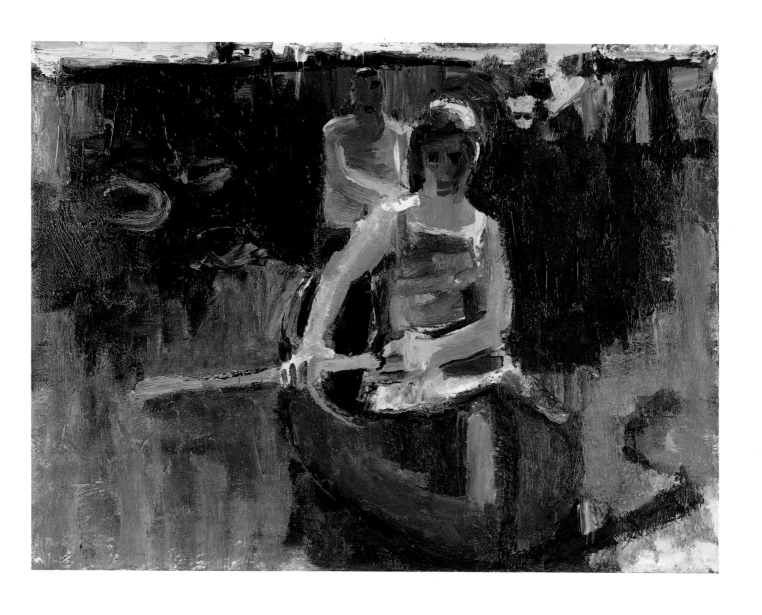

37.

Canoe, 1957

Oil on canvas, 36 × 48 inches

Sheldon Memorial Art Gallery, University of Nebraska, Lincoln;

Thomas C. Woods Memorial Collection, Nebraska Art Association

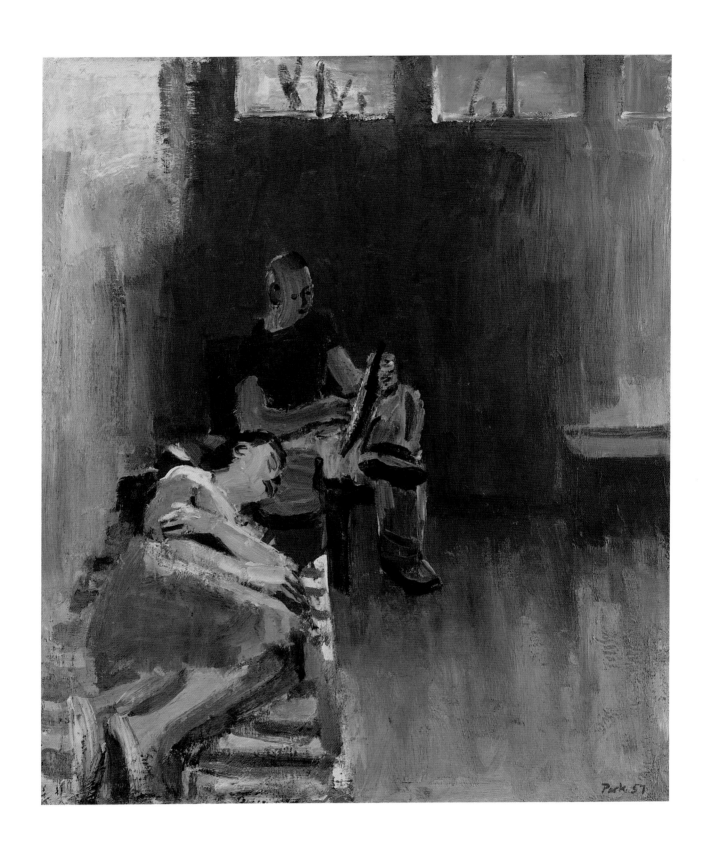

38.

Interior, 1957

Oil on canvas, 54 × 48 inches

Collection of Mr. and Mrs. Carl Lobell

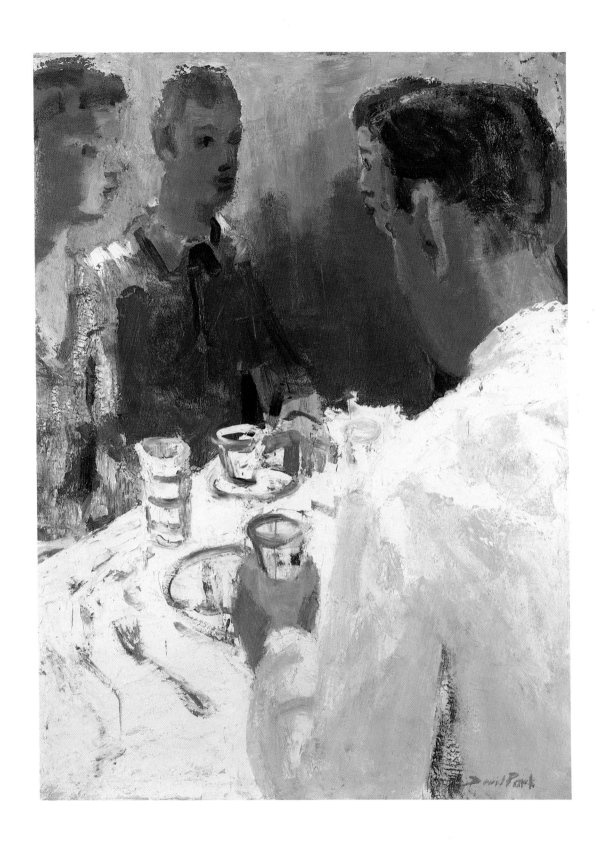

39.
The Table, 1957
Oil on canvas, 52 × 40 inches
Collection of Mrs. Paul L. Wattis

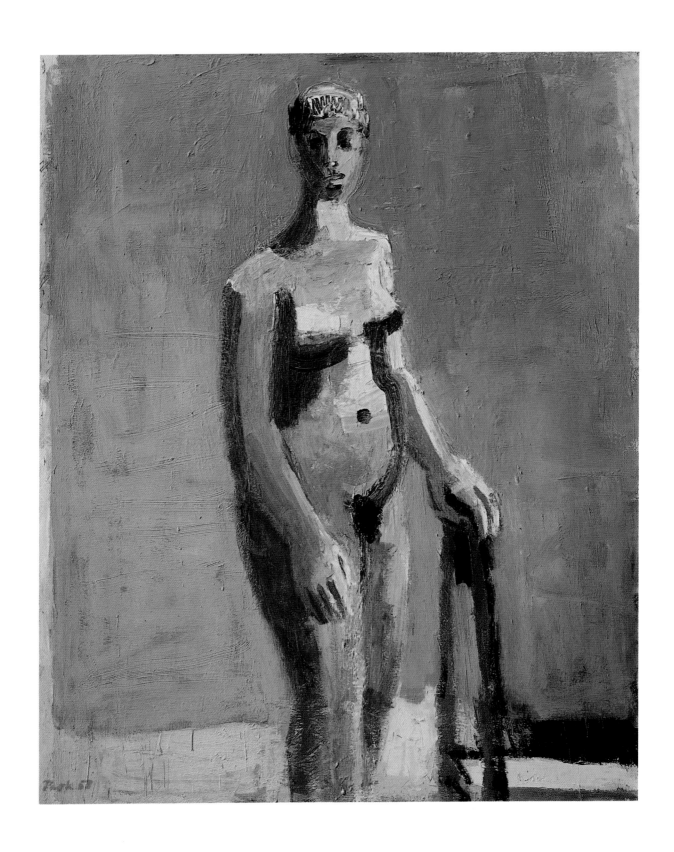

40.

Nude—Green, 1957

Oil on canvas, 68 × 56⅜ inches

Hirshhorn Museum and Sculpture Garden, Smithsonian Institution,

Washington, D.C.; Gift of Dr. and Mrs. Julian Eisenstein, Washington, D.C.

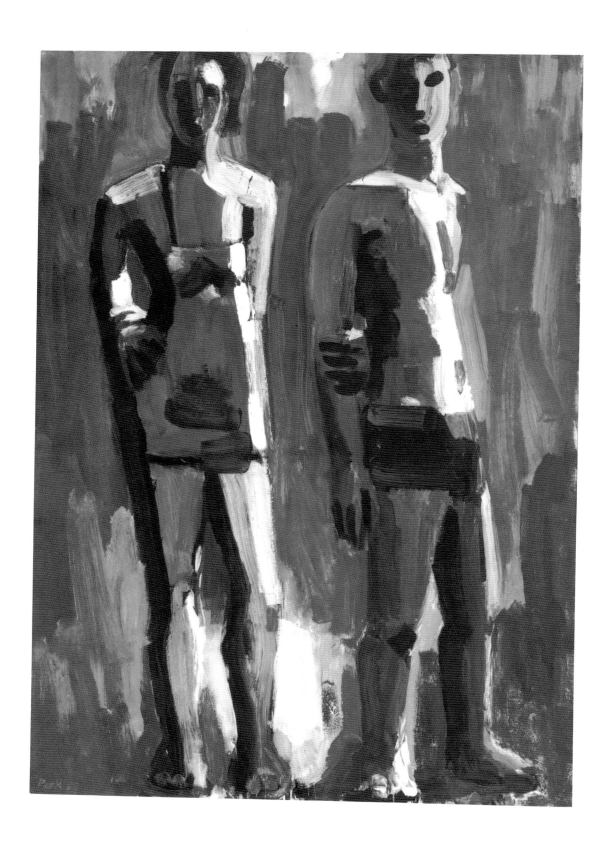

41.

Standing Couple, 1958

Oil on canvas, 75 × 57 inches

Krannert Art Museum, University of Illinois, Champaign-Urbana

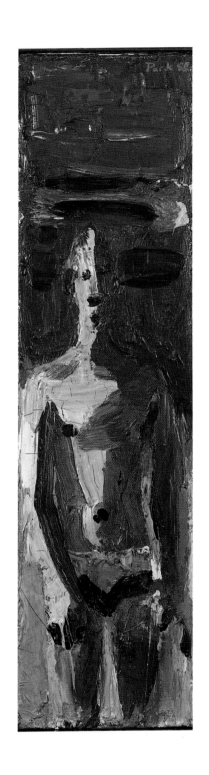

42.

Bather, 1958

Oil on canvas, 22 × 6½ inches

Collection of Allen and Frances Beatty Adler

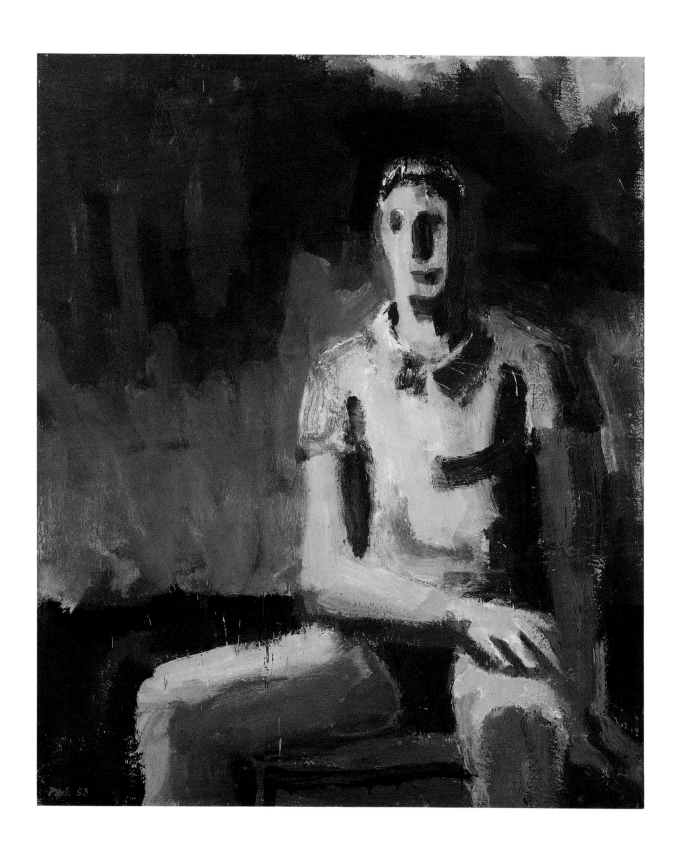

43.

Man in a T-Shirt, 1958
Oil on canvas, 59¾ × 49¾ inches
San Francisco Museum of Modern Art;
Gift of Mr. and Mrs. Harry W. Anderson

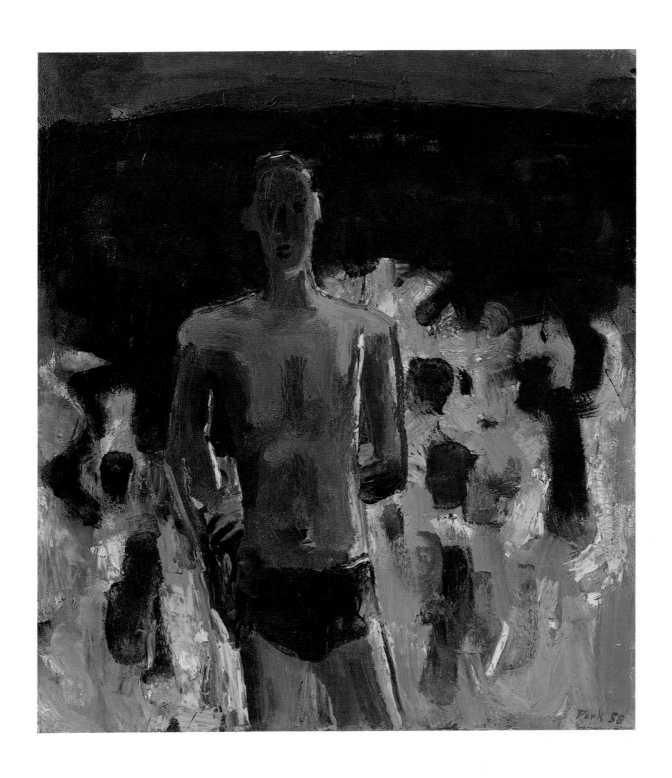

44.
Red Bather, 1958
Oil on canvas, 54 × 50 inches
The Steinmetz Family Collection

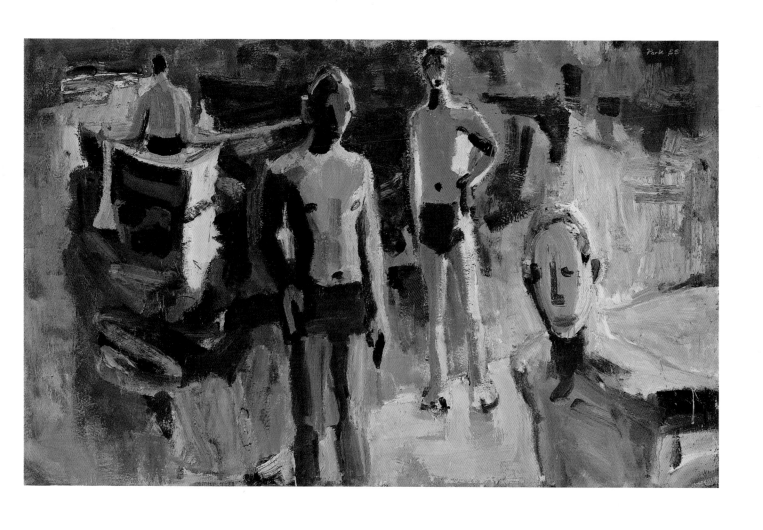

45.

Four Men, 1958

Oil on canvas, 57 × 92 inches

Whitney Museum of American Art, New York; Purchase,

with funds from an anonymous donor 59.27

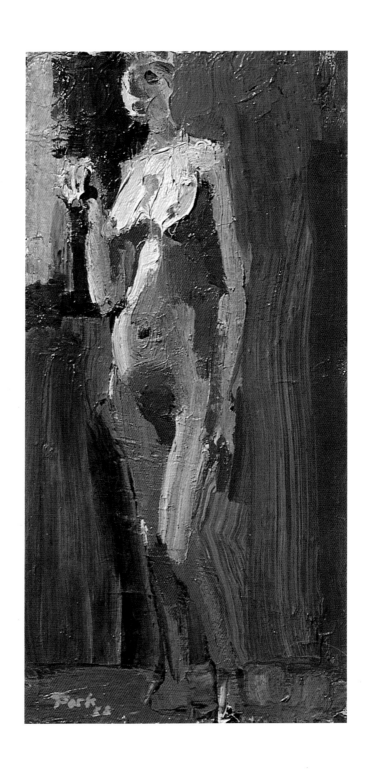

46.

Nude, 1958

Oil on canvas, 28⅛ × 14¼ inches

Collection of Mr. and Mrs. Roy Moore

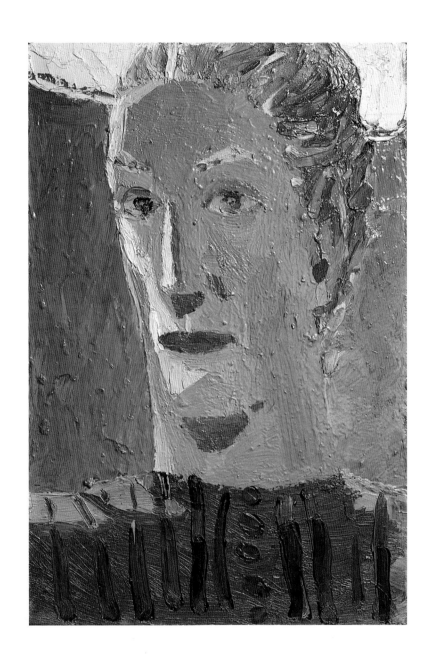

47.

Portrait of Mrs. C., 1958

Oil on canvas, 18⅛ × 12¼ inches

Private collection

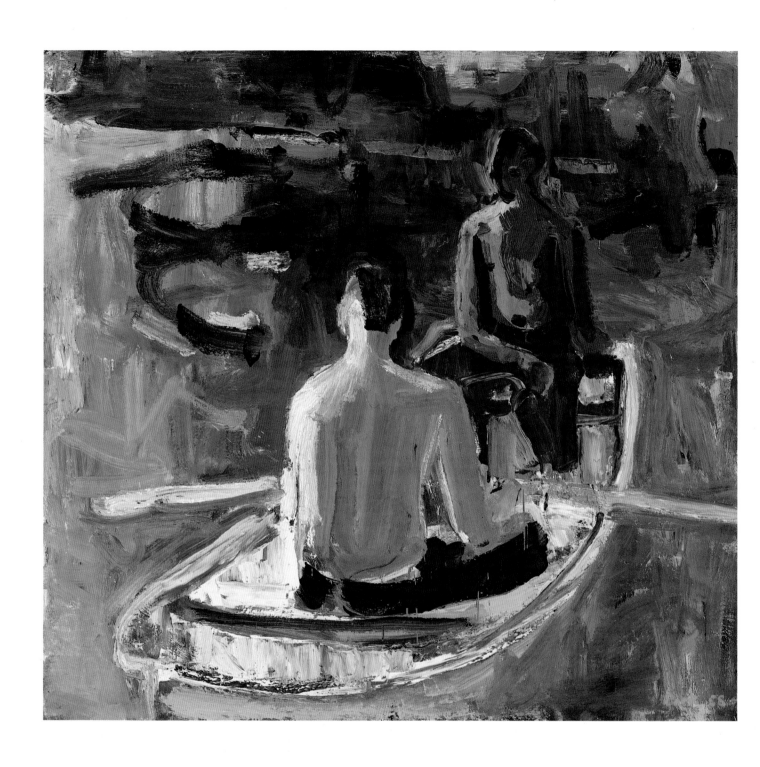

48.

Rowboat, 1958
Oil on canvas, 57 × 61 inches
Museum of Fine Arts, Boston; Anonymous Gift

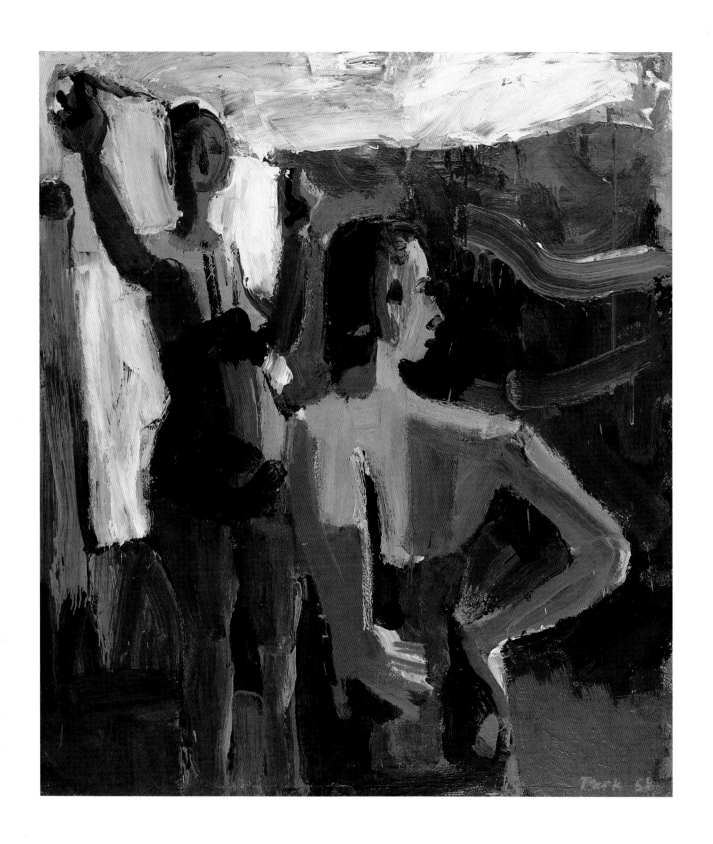

49.

Two Bathers, 1958

Oil on canvas, 58 × 50 inches

Collection of Mr. and Mrs. James R. Patton, Jr.

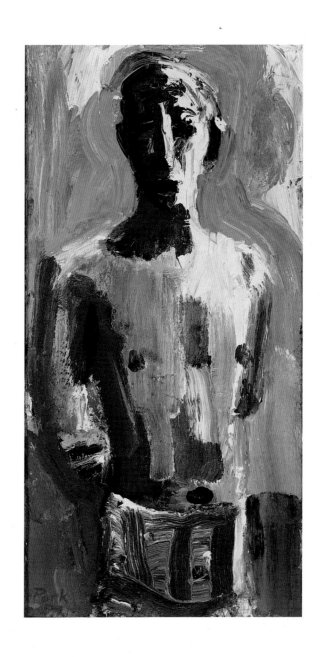

50.

Bather with Green Sea, 1959
Oil on canvas, 24 × 14 inches
Private collection

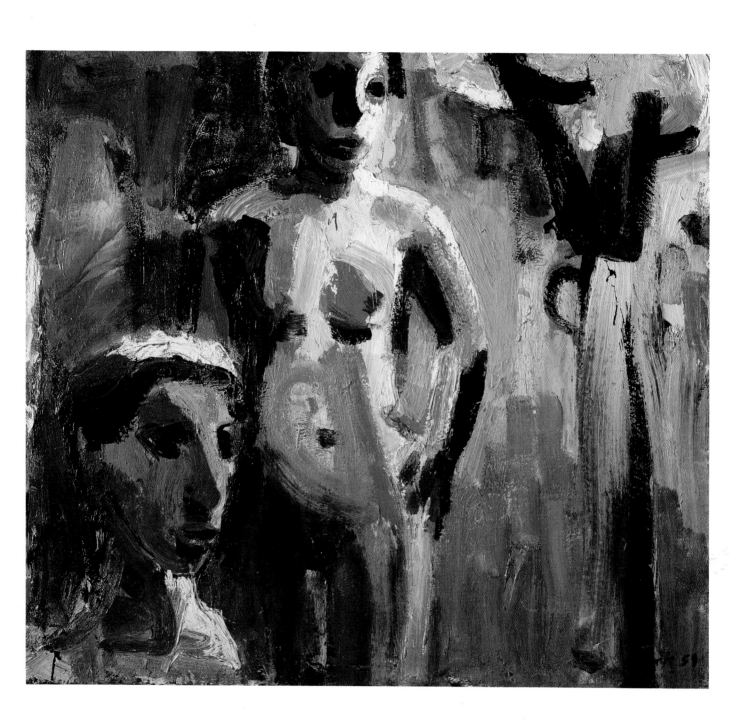

51.

Women in a Landscape, 1958
Oil on canvas, 50 × 56 inches
The Oakland Museum, California; Anonymous Donor
Program of the American Federation of Arts

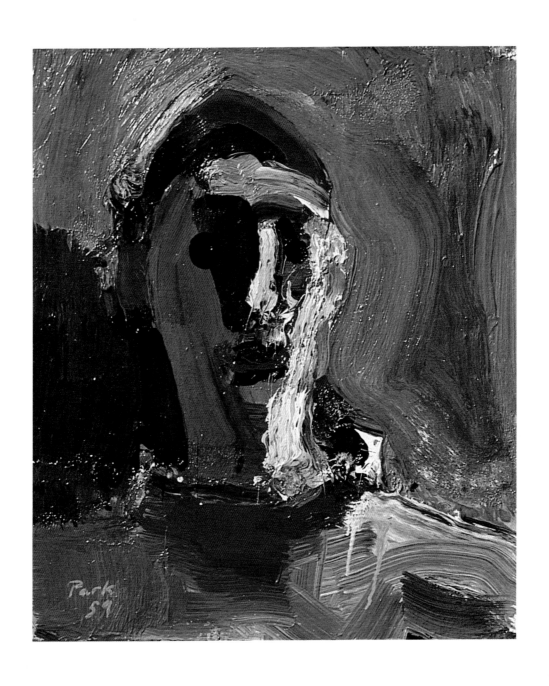

52.
Boy with Red Collar, 1959
Oil on canvas, 18⅞ × 16 inches
Collection of Mr. and Mrs. Roy Moore

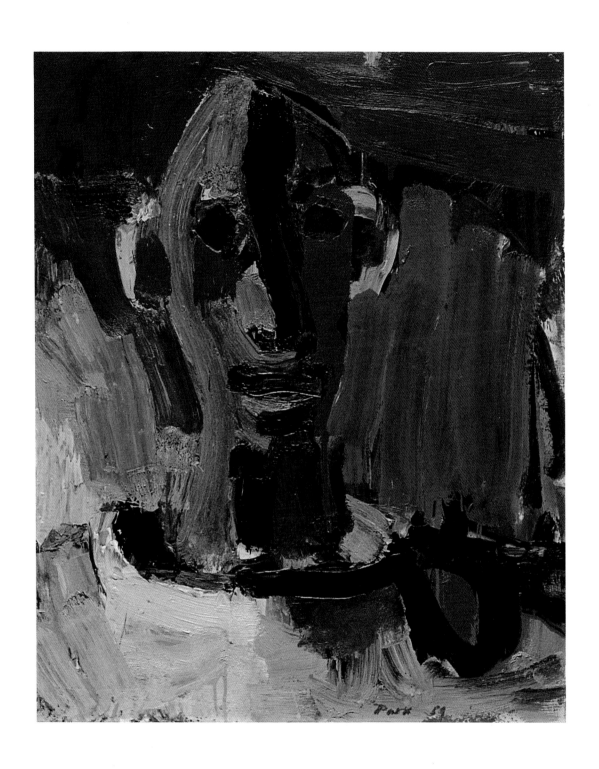

53.
Boy's Head, 1959
Oil on canvas, 32 × 26 inches
Collection of Arthur J. Levin

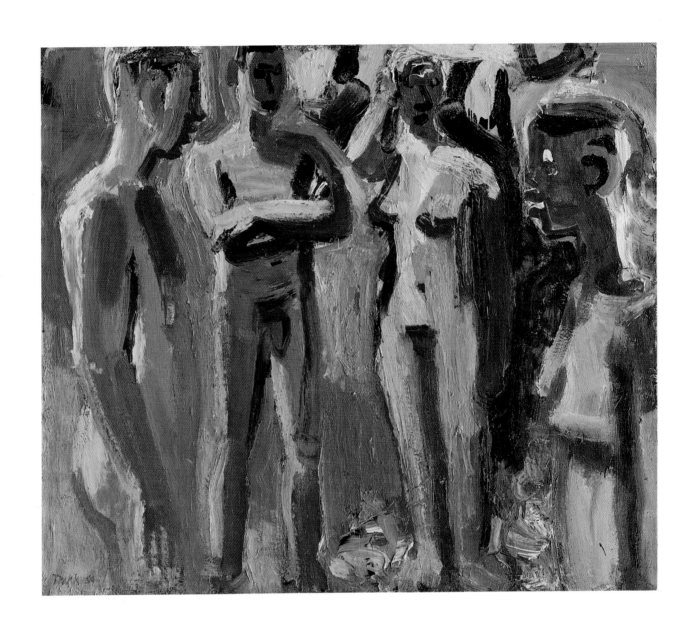

54.
Ethiopia, 1959
Oil on canvas, 52 × 60 inches
The Lowe Art Museum, University of Miami, Coral Gables;
Gift of Beaux Arts

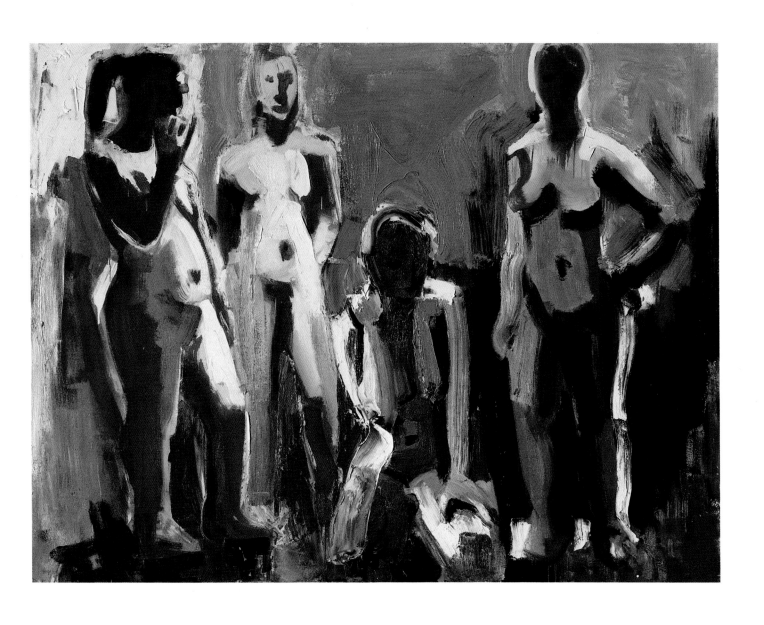

55.

Four Women, 1959

Oil on canvas, 57 × 75⅜ inches

Collection of Mr. and Mrs. Harry W. Anderson

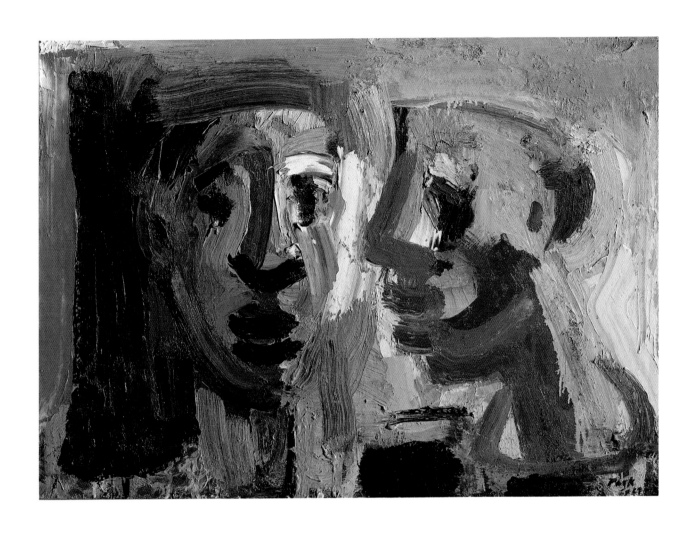

56.

Two Heads, 1959

Oil on canvas, 28½ × 40 inches

Collection of Mr. and Mrs. Harry W. Anderson

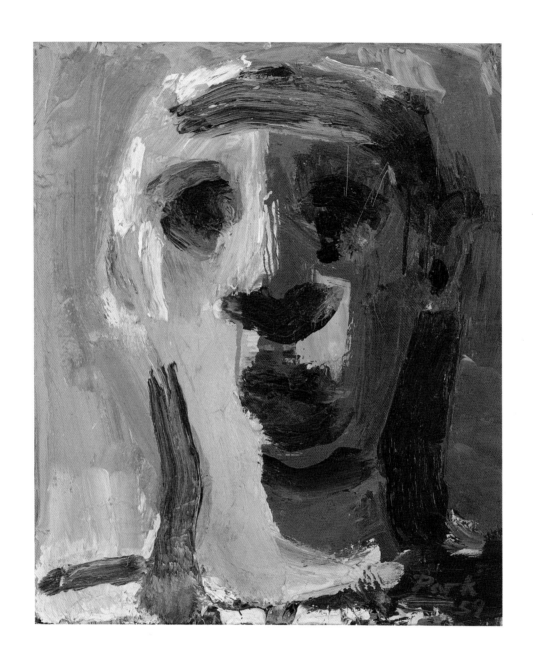

57.
Head, 1959
Oil on canvas, 19 × 16 inches
Collection of Mr. and Mrs. Jimmy J. Younger

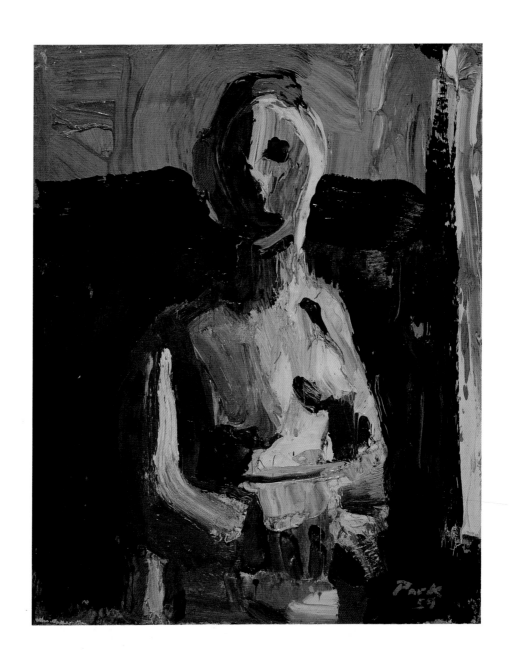

58.

Figure, 1959

Oil on canvas, 20 × 16 inches

Collection of Mrs. Robert M. Benjamin

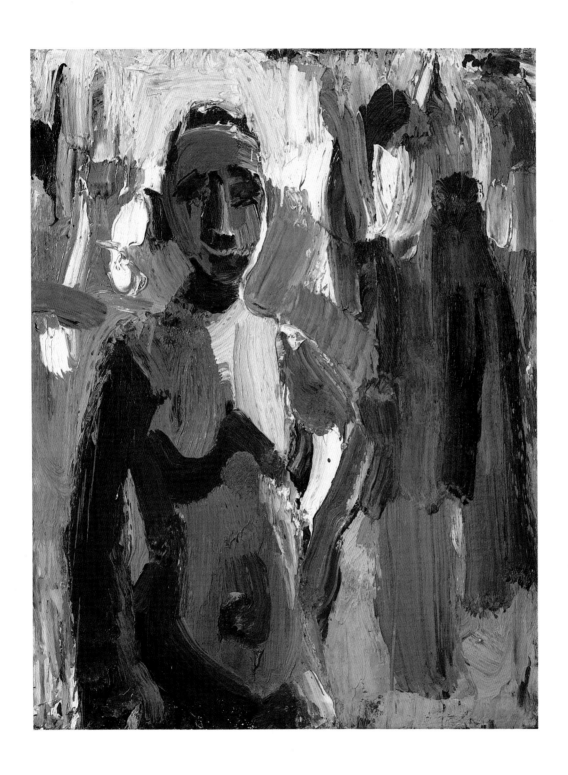

59.

Torso, 1959

Oil on canvas, 36⅜ × 27¾ inches

San Francisco Museum of Modern Art; Gift of The Women's Board

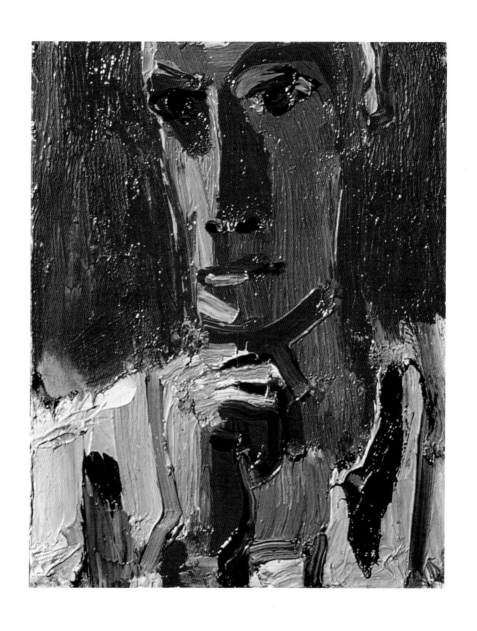

60.

Red Man in Striped Shirt, 1959

Oil on canvas, 18 × 14 inches

Collection of Natalie Park Schutz

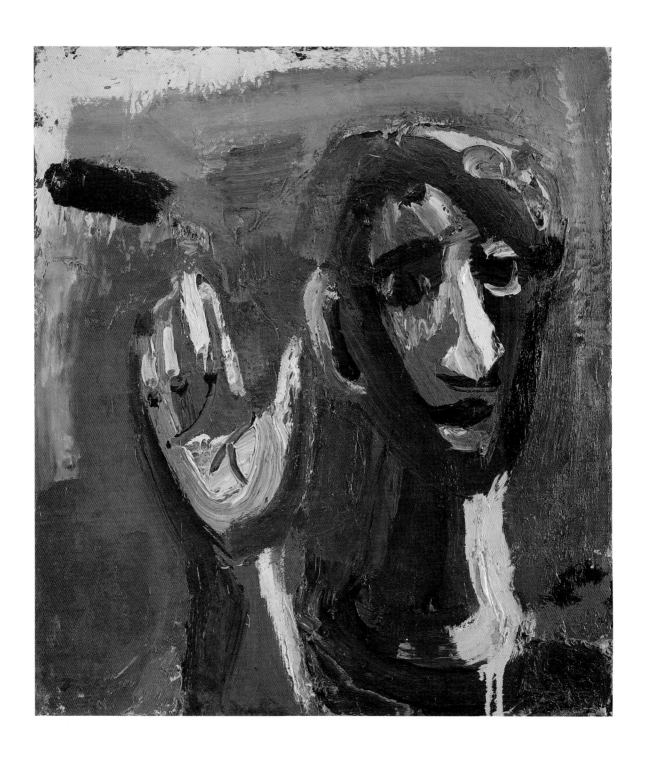

61.

Prophet, 1959

Oil on canvas, 28¼ × 25 inches

Collection of Mr. and Mrs. David Lloyd Kreeger

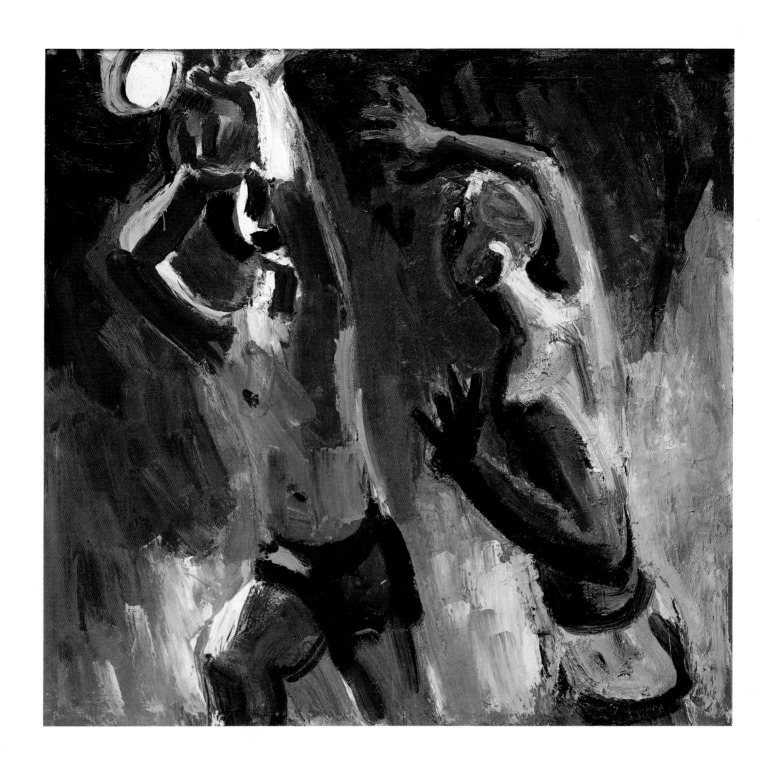

62.

Beach Ball, 1959

Oil on canvas, 56¾ × 60 inches

Collection of Byron R. Meyer

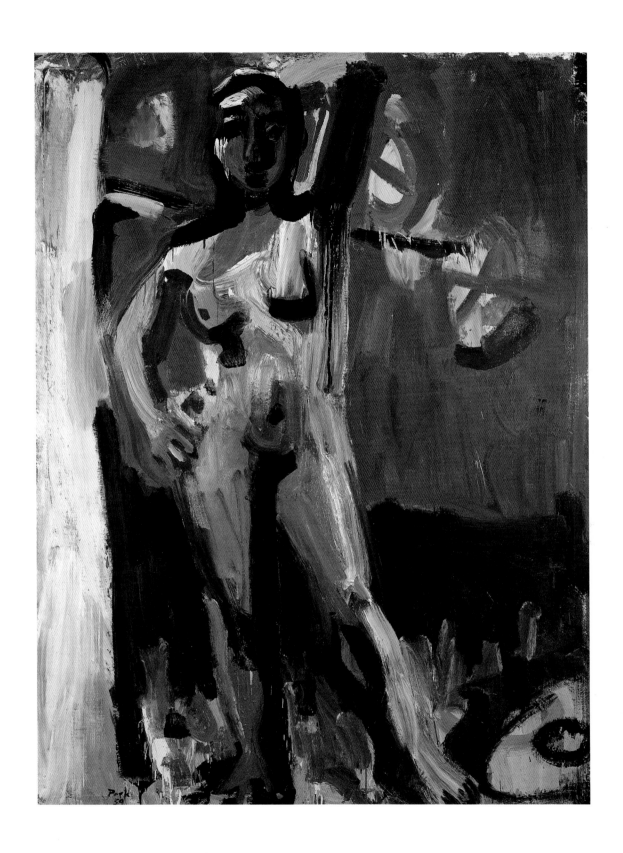

63.

Daphne, 1959

Oil on canvas, 75 × 57 inches

Collection of Mr. and Mrs. James R. Patton, Jr.

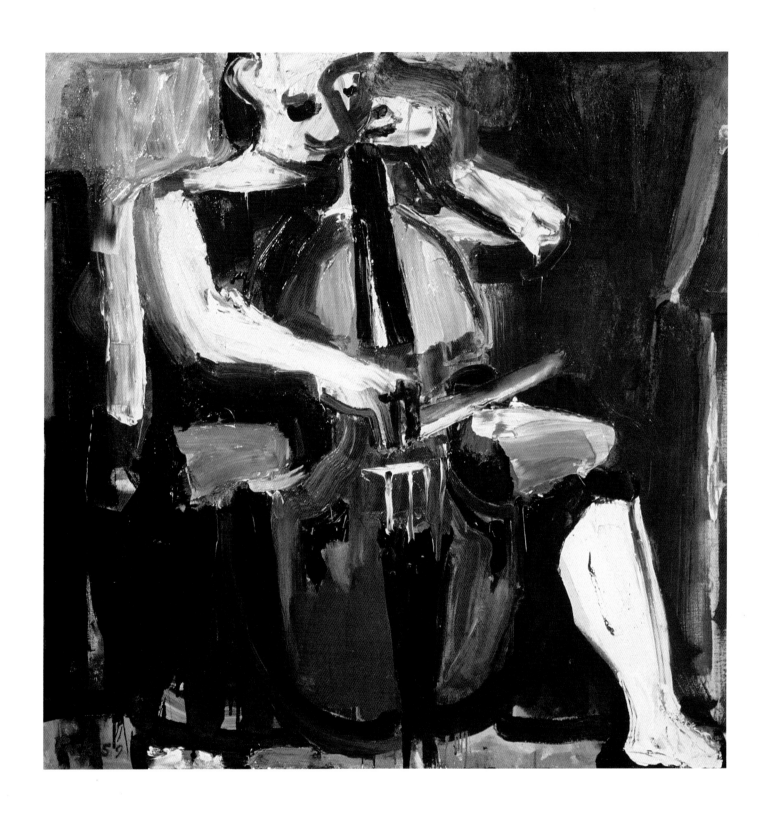

64.
The Cellist, 1959
Oil on canvas, 56 × 56 inches
Portland Art Museum, Oregon; Purchased with funds given anonymously

WORKS ON PAPER

65.
Head, c. 1955
Ink on paper, 17¾ × 11 inches
Collection of Suzanne Strid

66.

Untitled, c. 1955

Watercolor on paper, 15 × 13 inches

University Art Museum, University of New Mexico, Albuquerque

67.

Untitled (Reclining Male Nude), c. 1955
Ink on paper, 8½ × 11 inches
Collection of Byron R. Meyer

68.

Untitled (Male Nude, Foot on Stool), c. 1957
Graphite on paper, 14¾ × 12¾ inches
Collection of Suzanne Strid

69.
Untitled (Man), c. 1958
Ink on newsprint, 19 × 13 inches
Collection of Michael Chadbourne Mills

70.

Study for Interior, 1957

Watercolor on paper, 11 × 8½ inches

Collection of Dorothy and Robert E. Duffy

71.

Head, 1960

Gouache on paper, 11 × 8½ inches

Collection of Mr. and Mrs. James R. Patton, Jr.

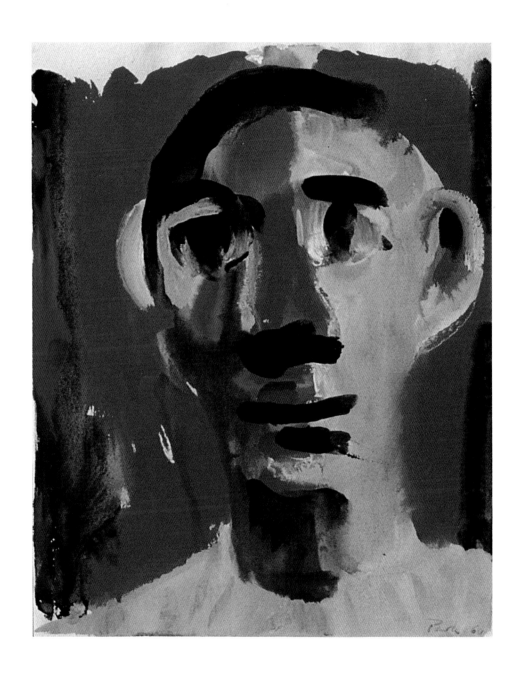

72.

Head, 1960
Gouache on paper, 9½ × 11½ inches
Collection of Nancy T. Park

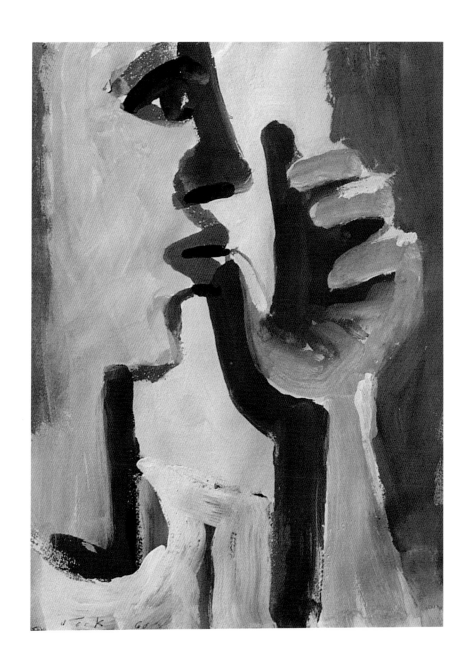

73.

Head with Hand, 1960

Gouache on paper, 12½ × 9¼ inches

Collection of Natalie Park Schutz

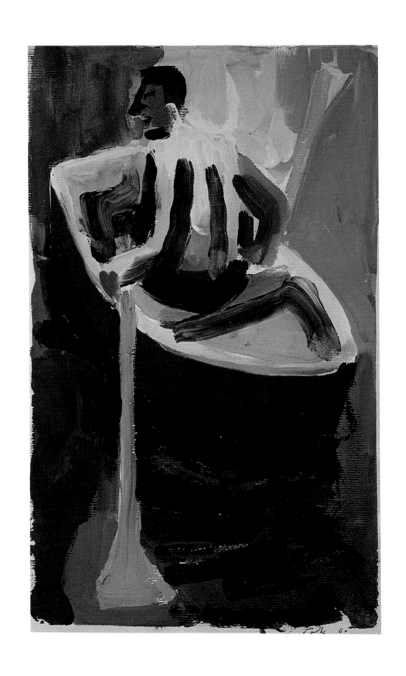

74.

Man in Rowboat, 1960

Gouache on paper, 11 × 8½ inches

Collection of Helen Park Bigelow

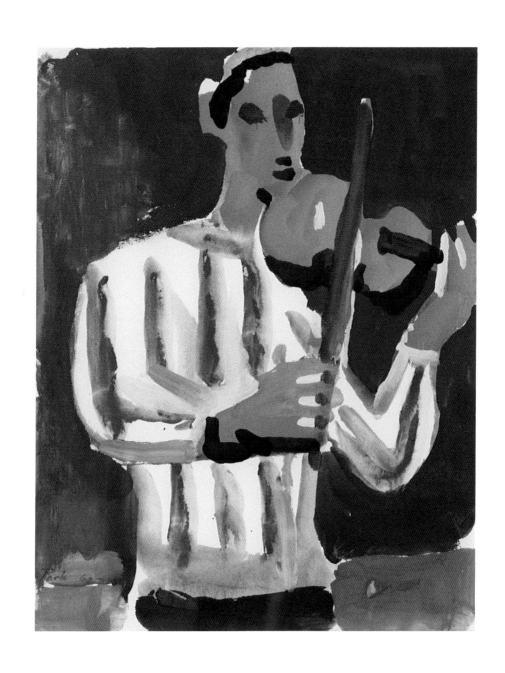

75.

Man Playing Violin in a Striped Shirt, 1960

Gouache on paper, 14 × 11 inches

Collection of Mr. and Mrs. Robert M. Montgomery, Jr.

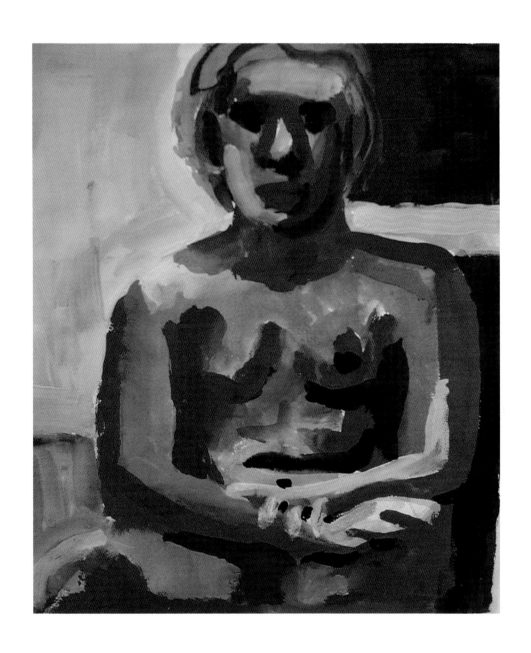

76.

Seated Figure, 1960

Gouache on paper, 14¾ × 13 inches

The Morgan Flagg Family Collection

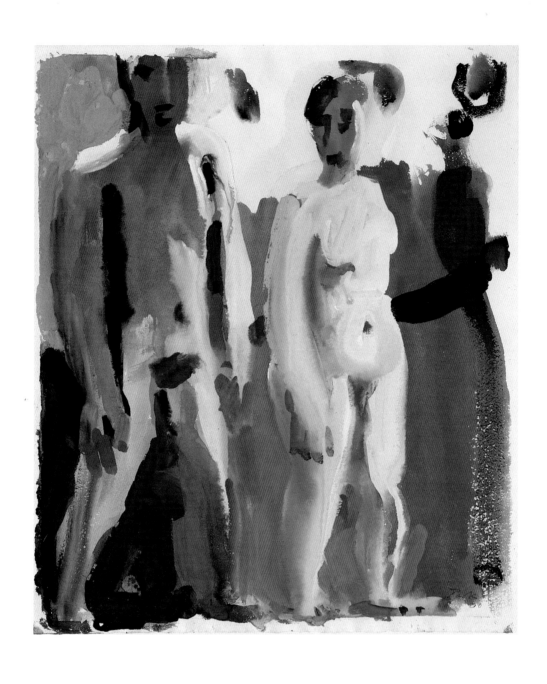

77.

Standing Nude Couple, 1960

Gouache on paper, 15½ × 13¼ inches

The Oakland Museum, California; Museum Donor's Acquisition Fund

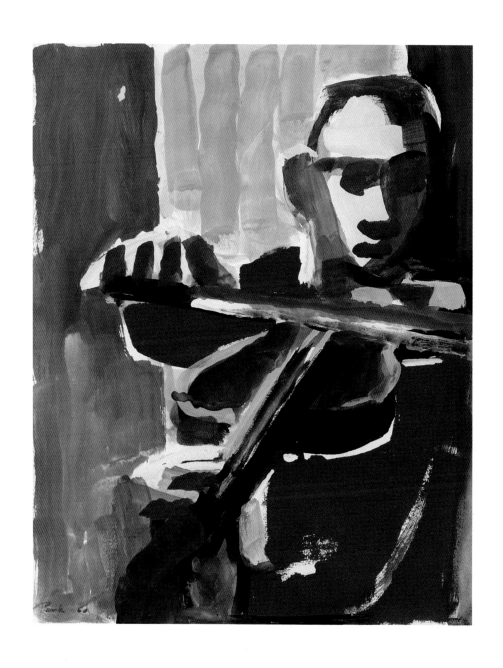

78.

Violinist, 1960
Gouache on paper, 14½ × 11½ inches
Collection of Mr. and Mrs. William L. McDonald, Jr.

79.
Untitled (Scroll), 1960
Felt pen on paper, 12 × 368¼ inches
University Art Museum, University of California, Berkeley;
Gift of Mrs. Benjamin H. Lehman

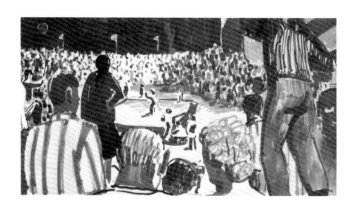

129

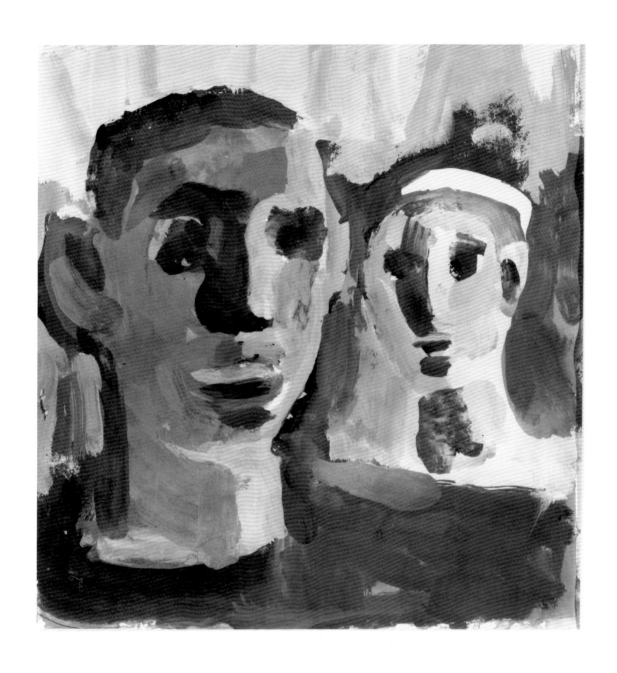

80.

Two Heads, 1960

Gouache on paper, 12½ × 12¼ inches

Whitney Museum of American Art, New York; Gift of

Mrs. Volney F. Righter 62.56

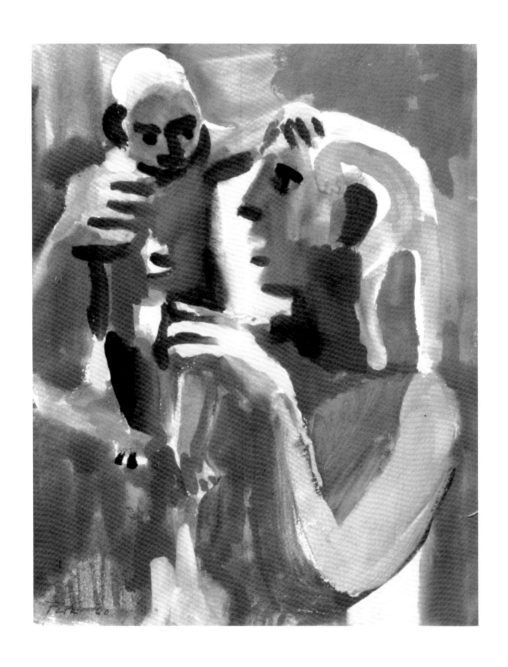

81.

Woman with Baby, 1960

Gouache on paper, 14 × 11 inches

Collection of Natalie Park Schutz

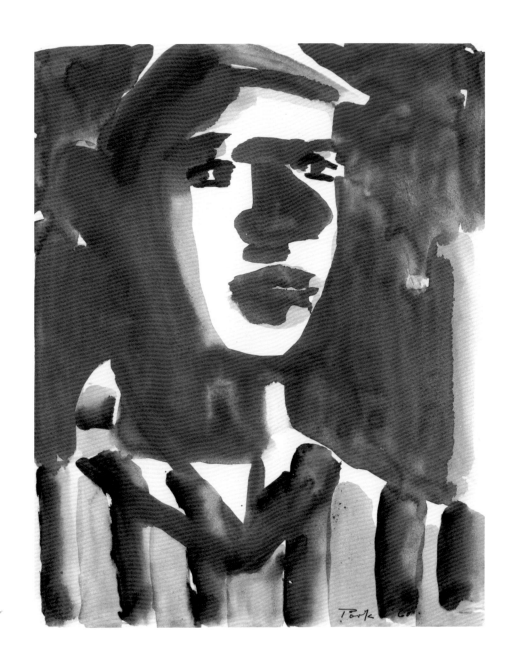

82.

Portrait of Richard Diebenkorn, 1960
Watercolor on paper, 10⅞ × 8¼ inches
The Museum of Modern Art, New York; Larry Aldrich
Foundation Fund

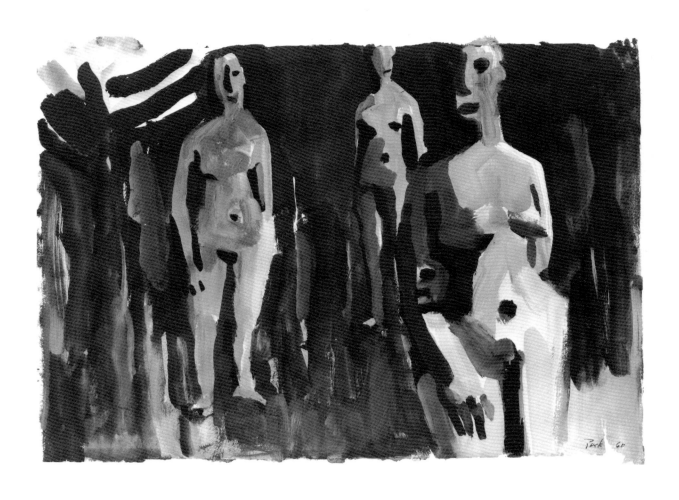

83.

Three Women Standing, 1960

Gouache on paper, 13¾ × 20 inches

Collection of Mr. and Mrs. Leon Campbell

NOTES

1. Sidney Tillim, "Month in Review," *Arts Magazine*, 36 (March 1962), p. 36.

2. Unless otherwise indicated, all biographical data about the artist is drawn principally from reminiscences by his brothers, Richard and Edwards Park, written at Betty Turnbull's request for the exhibition "David Park 1911–1960," Newport Harbor Art Museum, Newport Beach, California, 1977. Copies of their notes to Turnbull, as well as other Park memorabilia, were lent to me by the artist's daughters, Natalie Park Schutz and Helen Park Bigelow. They also supplied many other biographical details, as did Lydia Park Moore, Mrs. Richard Park, Mrs. Charles Cushing, and Gordon Newell, in conversations that took place in 1977 and 1978. Edwards Park and Marion Park Cogswell, David Park's surviving siblings, also supplied information; telephone interviews, August 1988.

3. Quoted in Paul Mills, "The Figure Reappears: The Art of David Park and Bay Area New Figurative Painting from 1950–1960," M.A. thesis, University of California, Berkeley, 1962, p. 18.

4. Both the Mills thesis, ibid., p. 18, and Betty Turnbull in *David Park 1911–1960*, exhibition catalogue, Newport Harbor Art Museum, Newport Beach, California, 1977, chronology, n.p., mistakenly claim that Park studied at Otis with Vaclav Vytlacil. The error may have arisen because Vytlacil lectured at Berkeley in the summer of 1929. Park may have attended these slide lectures on modern European painting. The Archives of Otis Art Institute have no records for Vytlacil, but those at University of California, Berkeley, document his lectures there.

5. Most of Park's WPA-era works have been destroyed; they are represented by unlabeled black-and-white photographs in the family's possession. Helen Park Bigelow was recently informed that the Mills College panels were seen at a community center in Mill Valley, California, where they had been inverted to serve as folding tables.

6. Quoted in the unsigned column "San Francisco Artists," *San Francisco Chronicle*, March 4, 1935.

7. Although it is unclear if Park ever knew Hofmann, he was a friend of such Hofmann enthusiasts as Glenn Wessels, a member of Berkeley's art faculty. As for Picasso, until the opening of the San Francisco Museum of Art in 1935, Park's knowledge of the artist must have been gained from reproductions.

8. The description was written by Frances Darwin Dugan, Director, Winsor School, Brookline, Massachusetts, for "Greetings and School News," *The Winsor Club Graduate Bulletin*, 1940.

9. For the most comprehensive analysis of this important period in San Francisco's artistic history, see Thomas Albright, *Art in the San Francisco Bay Area 1945–80* (Berkeley: University of California Press, 1985), in particular chapter 2, "Clyfford Still and the Explosion of Abstract Expressionism," and chapter 3, "The Golden Years of Abstract Expressionism." Interviews with the period's principal figures are published in Mary Fuller McChesney, *A Period of Exploration: San Francisco 1945–80*, exhibition catalogue, The Oakland Museum, 1973.

10. Quoted in Albright, *Art in the San Francisco Bay Area 1945–80*, p. 28.

11. Ibid., chapter 2.

12. Elmer Bischoff, among others, recalls Park's distaste for the Still faction; interview with the author, June 1, 1988.

13. Fred Martin, "Remembering 'The School,'" *Artweek*, 6 (November 1, 1975), p. 1.

14. Archives of the San Francisco Art Institute (the name of the California School of Fine Arts since 1960).

15. Ibid.

16. Quoted in Mills, "The Figure Reappears," p. 26.

17. George Stillman reported Park's dissatisfaction in an interview with Susan Landauer, who is preparing a dissertation on the California School of Fine Arts for Yale University; Landauer kindly sent me a transcription of the interview.

18. From a statement written by Park to accompany illustrations of his 1951–53 work in *The Artist's View*, no. 6 (September 1953), a small periodical published by a group called "Painters, Poets & Sculptors," San Francisco.

19. Mills, "The Figure Reappears," p. 41. *Kids on Bikes* was reproduced in the March 1951 *San Francisco Art Association Bulletin* and in *Arts Digest*, 25 (March 15, 1951).

20. Mills, "The Figure Reappears," p. 80.

21. Ibid., p. 60; Mrs. Bransten's reaction was related to me by her former daughter-in-law, Rena Bransten, in a conversation, February 1988.

22. Quoted in Mills, "The Figure Reappears," p. 90.

23. Albright, *Art in the San Francisco Bay Area 1945–80*, chapter 4. Albright synthesizes the history of this period and discusses Park's "lead" among figurative painters in the Bay Area.

24. "Contemporary Bay Area Figurative Painting" featured work by Park, Diebenkorn, Bischoff, Weeks, Paul Wonner, William Theo Brown, Walter Snelgrove, Bruce McGaw, Joseph Brooks, Robert Qualters, and Henry Villierme.

25. Quoted in Paul Mills, *Contemporary Bay Area Figurative Painting*, exhibition catalogue, The Oakland Museum, 1957, pp. 6–7.

26. See, for example, Brian O'Doherty, "Art: Retrospective of David Park's Work," *The New York Times*, December 5, 1961, p. 50. O'Doherty lauds Park's "exceptional honesty and power" as an artist. O'Doherty was generally positive about the contents of the show, though he cites "irritating mannerisms"—mostly in relation to Park's exuberant brushstrokes. He also notes that the later work seems incomplete, perhaps sketches of what might have followed if Park had lived.

27. Tillim, "Month in Review," p. 36.

EXHIBITIONS

AND SELECTED BIBLIOGRAPHY

Exhibitions are listed in chronological order; an asterisk (*) denotes a one-person exhibition. Catalogues are cited within the data on each exhibition; reviews immediately follow and are indented. Books and articles unrelated to exhibitions are listed at the end of each year.

1934 *East-West Gallery, San Francisco. "David Park."

*Oakland Art Gallery. "David Park."

1935 San Francisco Museum of Art. "55th Annual Exhibition of the San Francisco Art Association." January 18–March 3 (catalogue, with preface by Grace L. McCann Morley).

"San Francisco Artists." *San Francisco Chronicle*, March 4, 1935.

San Francisco Museum of Art. "Paintings by Bay Region Artists." June 23–July 26.

1936 San Francisco Museum of Art. "56th Annual Exhibition of the San Francisco Art Association." January 29–March 8 (catalogue).

"Juror Holds Mirror Up To Malcontents." *The Art Digest*, 10 (March 1, 1936), p. 8.

Ryder, Worth. "Picture Juries and the 56th Annual." *San Francisco Art Association Bulletin*, 2 (February 1936), pp. 6–7.

*San Francisco Museum of Art. "Stencil Prints from Genesis and Watercolors by David Park." February 20–March 23.

*Delphic Studios, New York. "David Park." April 6–May 3.

San Francisco Museum of Art. "Tempera Group Show." July 12–26.

"Local Artists Exhibit Tempera Works." *San Francisco News*, July 18, 1936.

1939 *New Gallery, Boston. "David Park."

*San Francisco Museum of Art. "Oils by David Park." November 25–December 18.

1940 *San Francisco Museum of Art. "Oils by David Park." Feburary 8–March 8.

1941 San Francisco Museum of Art. "61st Annual Exhibition of Painting and Sculpture of the San Francisco Art Association." September 11–October 5 (catalogue).

1942 San Francisco Museum of Art. "Sawdust and Spangles: Arts of the Circus." April 14–May 10.

1945 San Francisco Museum of Art. "12th Annual Watercolor Exhibition of the San Francisco Art Association." October 20–November 14 (catalogue).

San Francisco Museum of Art. "65th Annual Exhibition of the San Francisco Art Association." November 1–25 (catalogue).

1946 San Francisco Museum of Art. "11th Annual Exhibition: Art of the Bay Region."
January 18–February 5.

Rotunda Gallery, City of Paris Department Store, San Francisco. "Exhibition of Oils
and Watercolors." April 2–26.

*California Palace of the Legion of Honor, San Francisco. "David Park." August 14–
September 16.

"Park and Taylor Exhibits." *San Francisco Art Association Bulletin*, 12
(August 1946), n.p.

San Francisco Museum of Art. "66th Annual Exhibition of Painting and Sculpture of
the San Francisco Art Association." October 10–November 3 (catalogue).

1947 San Francisco Museum of Art. "New Works by Bay Region Artists." October 7–
November 2.

1948 San Francisco Museum of Art. "67th Annual Exhibition of Painting and Sculpture of
the San Francisco Art Association." February 4–29 (catalogue).

San Francisco Museum of Art. "Works of David Park, Elmer Bischoff, and Hassel
Smith." May 21–June 15.

Loran, Erle. "This Month in California: San Francisco." *Art News*, 48 (September
1949) pp. 45, 52–53.

San Francisco Museum of Art. "12th Annual Drawings and Prints Exhibition of the
San Francisco Art Association." June 9–July 4 (catalogue).

"From Where Is It?" *San Francisco Chronicle*, February 18, 1948.

"San Francisco: Division and Vivacity." *The New York Times*, October 24, 1948,
p. C9.

1949 San Francisco Museum of Art. "New Works by Bay Region Artists." August 2–
September 11.

1950 San Francisco Museum of Art. "New Works by Bay Region Artists: 15th
Anniversary." January 12–February 5.

San Francisco Museum of Art. "69th Annual Exhibition of Painting and Sculpture of
the San Francisco Art Association." February 10–March 12 (catalogue).

M.H. de Young Memorial Museum, San Francisco. "Members' Exhibition."
March 25–April 23.

"Berkeley Artist Is an Instructor and Talented Musician." *Berkeley Gazette*, February
2, 1950.

"Free Form Abstractions Stir Up Controversy." *San Francisco News*, March 18, 1950.

1951 San Francisco Museum of Art. "70th Annual Exhibition of Painting and Sculpture of
the San Francisco Art Association." February 28–April 8 (catalogue).

1952 University of Illinois, Champaign-Urbana. "Contemporary American Painting and
Sculpture." March 2–April 13.

San Francisco Museum of Art. "Art Makes Contact." March 26–May 4 (catalogue).

San Francisco Museum of Art. "Bay Region Painting and Sculpture." October 8–
November 9.

"Artist's Status Said Nothing to Fret Over." *Sacramento Union*, March 20, 1952, p. 8.

Loran, Erle, Weldon Kees, and Ernest Mundt. *Painting and Sculpture: The San
Francisco Art Association*. Berkeley: University of California Press, 1952.

1953 San Francisco Museum of Art. "72nd Annual Exhibition of Painting and Sculpture of the San Francisco Art Association." February 6–March 1 (catalogue).

"The Art 'Space Cadets' Are Now Evolving Their Own Vocabulary." *San Francisco Chronicle*, May 31, 1953, pp. 17, 19.

"San Francisco Art Association Members' Exhibition." *San Francisco Art Association Bulletin*, 10 (July 1953), n.p.

"Work of 16 Local Artists in San Francisco Art Association Annual." *Berkeley Daily Gazette*, May 1953.

*King Ubu Gallery, San Francisco. "Paintings by David Park." August 1–19.

Park, David. "David Park." *The Artist's View*, no. 6 (September 1953), n.p.

1954 San Francisco Museum of Art. "73rd Annual Exhibition of Painting and Sculpture of the San Francisco Art Association." February 18–March 28 (catalogue).

*Paul Kantor Gallery, Los Angeles. "David Park." June 14–July 16.

Langsner, Jules. "Summer in Los Angeles." *Art News*, 53 (June 1954), p. 58.

Frankenstein, Alfred. "Northern California." *Art in America*, 42 (Winter 1954), pp. 48–49, 74.

1955 San Francisco Museum of Art. "74th Annual Exhibition of Painting and Sculpture of the San Francisco Art Association." April 7–May 8 (catalogue).

Ferlinghetti, Lawrence. "San Francisco." *Arts Digest*, 29 (May 1, 1955), p. 16.

San Francisco Museum of Art. "Art in the 20th Century." June 17–July 10 (catalogue, with essay by Grace L. McCann Morley).

*Richmond Art Center, Richmond, California. "David Park." August 8–September 26.

Richmond Art Center, Richmond, California. "Fifth Annual Oil and Sculpture Exhibition." November 1–30.

1956 *College of Architecture, University of California, Berkeley. "David Park."

Museu de Arte Moderna, São Paulo, Brazil. "Pacific Coast Art: United States Representation at the III Biennial of São Paulo." July–October (brochure, with essay by Grace L. McCann Morley). Traveled to the Cincinnati Art Museum; Colorado Springs Fine Arts Center; San Francisco Museum of Art; Walker Art Center, Minneapolis.

"American Art in Brazil." *The New York Times*, September 4, 1956, p. C6.

Ashton, Dore. "An Eastern View of the San Francisco School." *Evergreen Review*, 1 (February 1956), pp. 148–59.

"Berkeley Painters Sell 11 Works to Art Collection." *Oakland Tribune*, June 21, 1956, p. 39E.

Crehan, Hubert. "Is There a California School?" *Art News*, 54 (January 1956), pp. 32–35.

1957 University of Illinois, Champaign-Urbana. "Contemporary American Painting and Sculpture." March 3–April 7.

The Oakland Museum. "California Painters Annual." March 9–31.

The Minneapolis Institute of Arts. "American Paintings 1945–1957." June 18–September 1 (catalogue).

Getlein, Frank. "Kidding the Id in Minneapolis." *The New Republic*, August 26, 1957, p. 21.

Richmond Art Center, Richmond, California. "Direction—Bay Area Painting—1957." August 1–September 25 (catalogue).

The Oakland Museum. "Contemporary Bay Area Figurative Painting." September 8–29 (catalogue, with essay by Paul Mills). Traveled (with additional paintings by David Park and Richard Diebenkorn from the Walter P. Chrysler, Jr. Collection) to the Los Angeles Museum of Art and the Dayton Art Institute, Ohio.

"Figurative Painters in California." *Arts*, 32 (December 1957), pp. 26–27.

1958 The Oakland Museum. "California Painters Annual." January 8–February 2.

Virginia Museum of Fine Arts, Richmond. "American Painting 1958." March 28–April 27 (catalogue, with essay by Grace L. McCann Morley).

San Francisco Museum of Art. "75th Annual Exhibition of Painting and Sculpture of the San Francisco Art Association." April 10–May 9 (catalogue).

Richmond Art Center, Richmond, California. "Eighth Annual Exhibition of Oil Paintings and Sculpture." October 30–December 7.

Chipp, Herschel. "This Summer in San Francisco." *Art News*, 58 (Summer 1958), p. 48

Seckler, Dorothy Gees. "Problems in Portraiture: Painting." *Art in America*, 46 (Winter 1958–59), pp. 22–37.

1959 University of Illinois, Champaign-Urbana. "Contemporary American Painting and Sculpture." March 1–April 5.

*M.H. de Young Memorial Museum, San Francisco. "David Park." March 26–April 26 (catalogue, with essay by David Park).

"At the de Young—The Poets and the Monumentalists." *San Francisco Chronicle*, April 5, 1959, p. 28.

Chipp, Herschel. "Art News from San Francisco." *Art News*, 58 (June 1959), p. 24.

Fried, Alexander. "Common Sense Prices for New Paintings." *San Francisco Examiner*, April 5, 1959, pp. 10, 11.

"Oils by David Park Shown at Museum." *Architect and Engineer*, 217 (April 1959), p. 4.

"Professor Park Exhibit at de Young." *Berkeley Daily Gazette*, March 26, 1959.

"Spring Comes to de Young." *Oakland Tribune*, April 5, 1959, p. 14S.

New York Coliseum. "Art USA." April 3–19.

*University of California, Berkeley, Department of Music. "May Formal: David Park Decors and Costume Design." May 14–25.

*Staempfli Gallery, New York. "David Park: Recent Paintings." September 30–October 17 (catalogue, with foreword by Thomas Carr Howe and statement by David Park).

"Art and Artists." *New York Journal American*, October 3, 1959, p. 7.

Ashton, Dore. "Reviews." *Arts and Architecture*, December 1959, pp. 76–77.

"Fine Park Exhibit." *New York Herald Tribune*, October 4, 1959, section 4, p. 10.

"Modern Pioneers." *The New York Times*, October 4, 1959, p. 13.

S[andler], I[rving] H. "Reviews and Previews: New Names This Month." *Art News*, 58 (September 1959) p. 12.

V[entura], A[nita]. "In the Galleries: David Park." *Arts*, 34 (September 1959), p. 60.

Whitney Museum of American Art, New York. "Annual Exhibition: Sculpture, Paintings, Watercolors, Drawings." November 19, 1959–January 4, 1960 (catalogue).

"Exhibition: Artists Choices Show Up At Whitney Museum." *New York Herald Tribune*, December 19, 1959.

The Detroit Institute of Arts. "Second Biennial of American Painting and Sculpture." November 29, 1959–January 3, 1960 (catalogue, with essay by A. Franklin Page).

"Art: 2nd American Biennial in Detroit Opens November 29, 1959, Plain But Honest." *The New York Times*, November 24, 1959, p. 75.

"The Image and the Void." *Time*, November 9, 1959, pp. 80–83.

Hunter, Sam. *Modern Painting and Sculpture*. New York: Dell Publishing Co., 1959.

1960 The Pennsylvania Academy of the Fine Arts, Philadelphia. "155th Annual Exhibition." January 24–February 28 (catalogue).

Florida State University Art Gallery, Tallahassee. "The First Exhibition of the Permanent Collection of F.S.U." February 2–21.

The Denver Art Museum. "66th Annual Exhibition" March 5–April 10.

Wildenstein & Co., New York. "Hallmark 5th International Art Award: The Question of the Future." October 5–26.

Staempfli Gallery, New York. "Elmer Bischoff, Richard Diebenkorn, David Park." November 8–26.

S[andler], I[rving]. "Reviews and Previews." *Art News*, 59 (December 1960), p. 15.

S[awin], M[artica]. "In the Galleries: Park, Bischoff, Diebenkorn at Staempfli." *Arts Magazine*, 35 (December 1960), p. 50.

The Oakland Museum. "David Park Memorial Exhibition." December 8–26.

Kramer, Hilton. "Month in Review." *Arts Magazine*, 34 (January 1961), pp. 42–45.

"David Park." *Art Journal*, 20 (Fall 1960), p. 30.

"David Park, UC Expert in Art, Dies." *Berkeley Daily Gazette*, September 21, 1960, p. 60.

Munro, Eleanor C. "Figures to the Fore." *Horizon*, 2 (July 1960) pp. 16–24, 114–16.

1961 The Art Institute of Chicago. "64th American Exhibition: Paintings, Sculpture." January 6–February 5.

*La Jolla Art Center, California. "David Park: Gouaches and Drawings." January 31–February 26.

Krannert Art Museum, University of Illinois, Champaign-Urbana. "Contemporary American Painting and Sculpture." February 27–April 18 (catalogue, with essay by Allen S. Weller).

*Artists Cooperative Gallery, Sacramento. "David Park." March 17–April 6.

Institute of Contemporary Art, Boston. "Provisional Collection." March (catalogue, with essay by Anne L. Jenks).

> Taylor, Robert. "Events in Art." *The Boston Sunday Herald*, January 14, 1962, p. A6.

Krannert Art Museum, University of Illinois, Champaign-Urbana. "A Selection from Josephine and P.A. Bruno Collection." November 11–December 3. Traveled to the Fine Arts Center, Nashville, Tennessee.

*Staempfli Gallery, New York. "David Park 1911–1960: Retrospective Exhibition." December 5–30 (catalogue, with essay by Paul Mills). Traveled to the Institute of Contemporary Art, Boston; Tennessee Fine Arts Center, Nashville; The Corcoran Gallery of Art, Washington, D.C.; The Oakland Museum; University Gallery, University of Minnesota, Minneapolis; Krannert Art Museum, University of Illinois, Champaign-Urbana; Washington University, St. Louis.

> "A David Park Retrospective." *Vista-Berkeley Daily Gazette*, May 19, 1962, p. 16.

> K[roll], J[ack]. "Reviews and Previews." *Art News*, 60 (January 1962), p. 11.

> Martin, Fred. "Oakland Museum Retrospective." *Artforum*, 1 (July 1962), pp. 35–36.

> Mills, Paul. "David Park." *Artforum*, 1 (July 1962), p. 36.

> O'Doherty, Brian. "Art: Retrospective Show of David Park's Work." *The New York Times*, December 5, 1961, p. C50.

> Polley, E.M. "Sampling of David Park's Art Shown at Oakland Museum." *Vallejo Times-Herald* (May 27, 1962), p. 38.

> Suzette. " 'Solitaire' has company." *Oakland Tribune*, March 12, 1962, p. 9.

> Taylor, Robert. "Events in Art." *The Boston Sunday Herald*, January 14, 1962, p. 6.

> "This Week Around the Galleries." *The New York Times*, December 10, 1961, p. C18.

> Tillim, Sidney. "New York Exhibitions: Month in Review." *Arts Magazine*, 36 (March 1962), pp. 36–40.

> "Traveling Exhibition Honors the Late David Park." *Oakland Tribune*, May 20, 1962, p. 15EL.

> Wallace, Dean. "The David Park Retrospective." *San Francisco Sunday Chronicle*, May 20, 1962, pp. 8–9.

1962 American Embassy, United States Information Service Gallery, London. "Vanguard American Painting." February 28–March 30 (catalogue).

The Obelisk Gallery, Washington, D.C. "Four University of California Painters." April 20–May 13.

Colorado Springs Fine Arts Center. "New Accessions USA." June 27–September 12.

Whitney Museum of American Art, New York. "Fifty California Painters." October 23–December 2 (catalogue, with introduction by George D. Culler). Traveled to the Walker Art Center, Minneapolis; Albright-Knox Art Gallery, Buffalo; Des Moines Art Gallery.

> Kozloff, Max. "New York Notes." *Art International*, 6 (February 1962), p. 1.

Amon Carter Museum, Fort Worth. "The Artist's Environment: The West Coast." November 5–December 23 (catalogue). Traveled to Dickson Art Center, University of California, Los Angeles; The Oakland Museum.

*Staempfli Gallery, New York. "David Park Watercolors 1960." December 18, 1962–January 12, 1963 (brochure, with statement by George W. Staempfli).

> Adlow, Dorothy. "Gouaches, Oils by Park on View." *The Christian Science Monitor*, January 3, 1963, p. 9.
>
> C[ampbell], L[awrence]. "Reviews and Previews." *Art News*, 61 (February 1963), p. 13.
>
> Kroll, Jack. "Reviews and Previews." *Art News*, 61 (February 1963), p. 13.
>
> Raynor, Vivien. "In the Galleries: Exhibition at Staempfli Gallery." *Arts Magazine*, 37 (February 1963), p. 49.
>
> Tillim, Sidney. "Month in Review." *Arts Magazine*, 36 (March 1962), pp. 36–37, 39–40.

"Art: Up From Goopiness." *Time*, April 27, 1962, pp. 48–49.

Chipp, Herschel B., B.H. Bronson, and G.A. Wessels. "David Park 1911–1960: Associate Professor of Art." *In Memoriam*, University of California, Berkeley, pp. 70–74.

Mills, Paul. "David Park and the New Figurative Painting." M.A. thesis. University of California, Berkeley.

"The Glorious Affair." *Time*, April 5, 1963, p. 59.

"The Human Figure Returns in Separate Ways and Places." *Life*, June 8, 1962, pp. 54–61.

"Sampling of David Park's Work." *Vallejo Times-Herald*, May 27, 1962, p. 38.

Wilder, Mitchell. "A Stirring in the Pacific Paint Pot." *Saturday Review*, October 20, 1962, pp. 56–58.

1963 Lieder, Philip. "California After the Figure." *Art in America*, 51 (October 1963), pp. 73–77.

Roland, Albert. "David Park: 1911–1960." *Ameryka* (in Polish); *America Illustrated*, no. 47, published by the Press and Publications Service, United States Information Agency, Washington, D.C., pp. 40–44.

1964 Staempfli Gallery, New York. "Seven California Painters: Bischoff, Brown, Diebenkorn, Park, Petersen, Weeks, Wonner." June (catalogue).

Whitney Museum of American Art, New York. "Between Fairs: 25 Years of American Art, 1939–1964." June 24–September 23 (catalogue, with introduction by John I.H. Baur).

*University Art Gallery, University of California, Berkeley. "David Park Memorial Exhibition: The University Years 1955–1960." October 6–November 8 (catalogue, with essay by Paul Mills). Traveled to the Dickson Art Center, University of California, Los Angeles; Art Gallery, University of California, Santa Barbara.

> Cross, Miriam Dugan. "Memorial Show for David Park." *Oakland Tribune*, October 11, 1964, p. 5EN.
>
> Frankenstein, Alfred. "The Human Form Returns to the Galleries." *San Francisco Chronicle*, October 11, 1964, pp. 29–30.
>
> "Park Exhibit to Show Last of UC Painter's Creations." *Berkeley Daily Gazette*, September 29, 1964, p. 11.

Polley, E.M. "Memorial to Park Exhibited." *Vallejo Times-Herald*, October 11, 1964, p. 44.

————. "University Art Museum Exhibition." *Artforum*, 3 (December 1964), p. 47.

Ventura, Anita. "San Francisco: The Proper Study?" *Arts Magazine*, 39 (January 1965), p. 78.

1965 Leeds City Art Gallery, England. "American Paintings from the Bloedel Collection." May 31–July 3 (catalogue, with introduction by John W. McCoubrey). Traveled to the Chelsea School of Art, London.

Bell, Quentin. "American Paintings from the Bloedel Collection." *The Listener*, April 15, 1965, p. 566.

Greenville County Museum of Art, South Carolina. "Collection of Paintings and Sculpture from Mr. and Mrs. A.H. Maremont." December 16, 1965–January 23, 1966 (catalogue).

Wholden, R.G. "Los Angeles: The Relay Race." *Arts Magazine*, 39 (February 1965), p. 78.

1966 J.L. Hudson Gallery, Detroit. "Four California Painters." February 9–March 2.

*E.B. Crocker Art Gallery, Sacramento. "David Park: University Years—1955." April 10–May 1.

Polley, E.M. "San Francisco." *Artforum*, 4 (June 1966), p. 50.

1967 Yale University Art Gallery, New Haven. "The Helen W. and Robert M. Benjamin Collection." May 4–June 18.

1968 *San Jose State College Art Department. "A Tribute to David Park." February 26–March 8.

" 'Tribute to David Park' at SJS." *San Jose Mercury-News*, February 25, 1968, p. 5E.

"Abstract Exhibit by David Park at SJS Gallery for Two Weeks." *Spartan Daily*, February 27, 1968.

San Francisco Museum of Art. "On Looking Back." August 10–September 8.

*Santa Barbara Museum of Art. "David Park: His World 1911–1960." October 19–November 17 (catalogue, with essay by Goldthwaite H. Dorr III).

"David Park Retrospective Show to Open." *Santa Barbara News-Press*, October 6, 1968, p. C14.

"Retrospective Exhibit of David Park's Work." *Santa Barbara News-Press*, October 13, 1968, p. D14.

"Retrospective Exhibition of David Parks Shown." *Santa Barbara News-Press*, October 20, 1968, p. C10.

1970 Crocker Citizens Plaza, Los Angeles. "A Century of California Painting 1870–1970." June 1–30 (catalogue, with essays by Joseph Armstrong Baird, Jr., Paul Mills, Kent L. Seavey, Mary Fuller McChesney, Dr. Alfred Frankenstein). Traveled to Fresno Art Center; Santa Barbara Museum of Art; California Palace of the Legion of Honor, San Francisco; de Sassaiet Gallery, University of Santa Clara; California; E.B. Crocker Art Gallery, Sacramento; The Oakland Museum.

* Maxwell Galleries, San Francisco. "David Park: A Retrospective Exhibition." August 14–September 26 (catalogue, with essay by Paul Mills).

> Bloomfield, Arthur. "Tribute to a Great Local Artist." *San Francisco Examiner*, August 18, 1970.

> Frankenstein, Alfred. "Park Painted Up a Storm: A Vital Monument." *San Francisco Chronicle*, August 20, 1970, p. 47.

> Jaszi, Jean. "David Park Retrospective." *Artweek*, 1 (September 12, 1970), p. 3.

1971 Fuller, Mary. "Was There a San Francisco School?" *Artforum*, 9 (January 1971), pp. 46–53.

Webster, Tom, ed. "Three Drawings: David Park." *Spectrum*, 13 (Spring 1971), pp. 34–37.

———. "The Drawings of David Park." *Spectrum*, 13 (Winter 1971), pp. 32–36.

1973 The Oakland Museum. "A Period of Exploration, San Francisco 1945–1950." September 4–November 4 (catalogue, with essay by Mary Fuller McChesney).

* Maxwell Galleries, San Francisco. "David Park (1911–1960): An Exhibition of Oil Paintings, Drawings, and Watercolors." September 21–October 13 (catalogue).

> Frankenstein, Alfred. "Park and the Figure: A Defier of Dogma." *San Francisco Chronicle*, October 2, 1973, p. 40.

1974 * Adele Bednarz Galleries, Los Angeles. "David Park: Oils, Gouaches, Drawings." May 20–June 20.

Plagens, Peter. *The Sunshine Muse: Contemporary Art on the West Coast.* New York: Praeger Publishers, 1974, pp. 56–59.

1975 Hansen Fuller Gallery, San Francisco. "Tribute to the San Francisco Art Institute." October 20–November 29.

> Martin, Fred. "Remembering 'the School' (Part I)." *Artweek*, 6 (November 1, 1975), pp. 1, 16–18.

> ———. "Remembering 'the School' (Part II)." *Artweek*, 6 (November 8, 1975), pp. 6–7.

> ———. "Remembering 'the School' (Part III)." *Artweek*, 6 (November 15, 1975), pp. 3–4.

Museum of Fine Arts of St. Petersburg, Florida. "Figure as Form, American Painting 1930–1975." November 25, 1975–January 4, 1976 (catalogue, with essay by Margaret A. Miller). Traveled to the Florida Center for the Arts, University of South Florida, Tampa; Columbus Museum of Arts and Sciences, Columbus, Georgia.

> Albright, Thomas. "Park's Conflict Between Abstraction, Representation." *San Francisco Chronicle*, April 12, 1975, p. 31.

> Coffelt, Beth. "The Big Wave Was Rising." *San Francisco Sunday Examiner and Chronicle*, November 9, 1975, magazine section, pp. 24–28.

> Stepan, R.F. "David Park Paintings." *Artweek*, 6 (April 19, 1975), p. 4.

1976 San Francisco Museum of Modern Art. "Painting and Sculpture in California: The Modern Era." September 3–November 21 (catalogue, with essay by Henry T. Hopkins). Traveled to the National Collection of Fine Arts, Smithsonian Institution, Washington, D.C.

* Maxwell Galleries, San Francisco. "A Retrospective Exhibition." September 14–October 25.

1977 The Oakland Museum. "Archives of American Art: California Collecting." February 1–March 20 (catalogue, with introduction by Paul J. Karlstrom).

Whitney Museum of American Art, New York, "Selections from the Lawrence H. Bloedel Bequest." April 5–June 19 (catalogue, with essay by Irwin Shainman).

*Newport Harbor Art Museum, Newport Beach, California. "David Park 1911–1960." September 16–November 13 (catalogue, with essay by Betty Turnbull). Traveled to The Oakland Museum.

> Albright, Thomas. "The Shaky Position of a 'New Realist.'" *San Francisco Examiner and Chronicle*, December 18, 1977, p. 48.
>
> "David Park—Figuratively Speaking." *The Museum of California* (Oakland), 1 (December 1977), pp. 13–14.
>
> Dreyfuss, John. "Newport Museum: A Lot for a Little." *Los Angeles Times*, September 25, 1977, calendar section, p. 78.
>
> Hopkins, Mary Lou. "Museum Makes an Exhibition of Itself." *Los Angeles Times* (View Section, Orange County), September 16, 1977, pp. 1, 8.
>
> Lewis, Louise. "Newport Harbor—Two Exhibits, A New Facility, A New Director." *Artweek*, 8 (September 24, 1977), pp. 1, 16.
>
> Perl, Jed. "David Park at The Oakland Museum." *Art in America*, 66 (July 1978), p. 120.
>
> Shere, Charles. "Back from Ab Ex: The Painting of David Park." *Oakland Tribune*, December 18, 1977, p. 21E.
>
> Wilson, William. "Newport Gives Berth to Park Retrospective." *Los Angeles Times*, September 25, 1977, calendar section, p. 79.

1978 Whitney Museum of American Art, New York. "American Art 1950–Present." May 3–September 10 1978.

Albright, Thomas. "Bay Area Figurative." *Art News*, 77 (February 1978), pp. 102–03.

1980 Whitney Museum of American Art, New York. "The Figurative Tradition and the Whitney Museum of American Art." June 25–September 28 (catalogue, with essays by Patricia Hills and Roberta K. Tarbell).

University Gallery, University of Tennessee, Chattanooga. "20th Century American Painting." September 8–October 3.

California State College, Stanislaus, California. "Bay Area Figurative Works." November 9–26 (catalogue, with essay by Hope Werness).

1981 E.B. Crocker Art Gallery, Sacramento. "From Exposition to Exposition: Progressive and Conservative Northern California Painting 1915–1939." September 4–October 11 (catalogue, edited by Joseph Armstrong Baird, Jr.)

Haus der Kunst, Munich. "Amerikanische Malerei: 1930–1950." November 14, 1981–January 31, 1982 (catalogue, with essay by Tom Armstrong).

McCall, Dewitt Clinton, III. *California Artists: 1935–1956*. Bellflower, California: DeRu's Fine Art Books, 1981.

1982 Rutgers University Art Gallery, New Brunswick, New Jersey. "Realism and Realities: The Other Side of American Painting, 1940–1960." January 17–March 26 (catalogue, with essays by Greta Berman and Jeffrey Wechsler). Traveled to the Montgomery Museum of Fine Arts, Alabama; Grand Central Art Galleries, New York; Art Gallery, University of Maryland, College Park.

Terra Museum of American Art, Evanston, Illinois. "Solitude: Inner Visions in American Art." September 25–December 30 (catalogue, with essay by David M. Sokol).

The Art Museum of Santa Cruz County, Santa Cruz, California. "Selections from Local Collections: Twentieth Century Paintings, Prints and Drawings." October 24–December 5.

1983 Richard L. Nelson Gallery and the Memorial Union Art Gallery, University of California at Davis. "Directions in Bay Area Painting: A Survey of Three Decades, 1940s–1960s." April 12–May 20 (catalogue, edited by Joseph Armstrong Baird, Jr.).

*Salander-O'Reilly Galleries, New York. "David Park 1911–1960: Paintings and Drawings." October 1–29 (catalogue, with essays by Carl Belz and Richard Diebenkorn).

> Brenson, Michael. "David Park: Paintings and Drawings, 1948–60." *The New York Times*, September 16, 1983, p. 18.
>
> Klein, Ellen Lee. "In the Galleries: David Park at Salander-O'Reilly." *Arts Magazine*, 58 (November 1983), p. 38.
>
> Smith, Roberta. "Old Timers as New Comers." *The Village Voice*, October 4, 1983, p. 115.
>
> Westphal, Stephen. "David Park at Salander-O'Reilly Gallery." *Art in America*, 71 (November 1983), p. 219.

Belz, Carl. "To Acknowledge the Self: The Paintings of David Park." *Arts Magazine*, 58 (September 1983), pp. 66–68.

1984 The Grey Art Gallery and Study Center, New York University, New York. "The Figurative Mode: Bay Area Painting." June 20–September 15 (catalogue, with essay by Christopher Knight). Traveled to the Newport Harbor Art Museum, Newport Beach, California.

> Raynor, Vivien. "Art: California School." *The New York Times*, March 30, 1984, p. C26.
>
> Schipper, M. "Looking Back in Two Directions." *Artweek*, 15 (August 25, 1984), p. 1.

P.S. 1, The Institute for Art and Urban Resources, Long Island City, New York. "Underknown: Twelve Artists Re-seen in 1984." October 14–December 9 (catalogue, with essay by Henry Geldzahler).

Orr-Cahall, Christina, ed. *The Art of California: Selected Works from the Collection of the Oakland Museum.* Oakland: The Oakland Museum, 1984.

1985 *Salander-O'Reilly Galleries, New York. "David Park." September 4–October 26 (catalogue, with essay by Henry Geldzahler).

> Baker, Kenneth. "Bay Area Painter's Stirring New York Survey." *San Francisco Chronicle*, October 21, 1985, p. 59.
>
> Brenson, Michael. "Art: Show Focuses on David Park." *The New York Times*, September 6, 1985, p. C19.
>
> Gill, Susan. "David Park: Salander-O'Reilly." *Art News*, 84 (November 1985), p. 147.
>
> Harding, Robert. "David Park and Porter." *Art World*, October 1985, pp. 1, 8.

Klein, Ellen Lee. "David Park at Salander-O'Reilly Gallery." *Arts Magazine*, 60 (November 1985), p. 133.

Schwartz, Sanford. "The Art World: David Park." *The New Yorker*, October 28, 1985, pp. 88–93.

San Francisco Museum of Modern Art. "American Realism: Twentieth-Century Drawings and Watercolors." November 7–January 12, 1986 (catalogue, with essay by Alvin Martin). Traveled to De Cordova and Dana Museum and Park, Lincoln, Massachusetts; Archer M. Huntington Art Gallery, University of Texas, Austin; Mary and Leigh Block Gallery, Northwestern University, Evanston, Illinois; Williams College Museum of Art, Williamstown, Massachusetts; Akron Art Institute, Ohio; Madison Art Center, Wisconsin.

Albright, Thomas. *Art in the San Francisco Bay Area 1945–1980: An Illustrated History.* Berkeley and Los Angeles: University of California Press, 1985.

Van Proyen, M. "Commemorating a Critic's Eye." *Artweek*, 16 (July 13, 1985).

1986 *The Oakland Museum. "Recent Acquisitions, 6 Paintings by David Park." January–March.

Baker, Kenneth. "Oakland's New Park Paintings." *San Francisco Chronicle*, January 8, 1986, p. 54.

University Art Museum, University of California, Berkeley. "California Collects I." April 2–May 18.

1987 *Salander-O'Reilly Galleries, New York. "David Park (1911–1960)." January 7–February 28 (catalogue, with essays by Howard Baker, Carl Belz, Richard Diebenkorn, Henry Geldzahler, and Phyllis Tuchman).

Moorman, Margaret. "David Park: Salander-O'Reilly." *Art News*, 68 (Summer 1987), p. 208.

Smith, Roberta. "Art: 47 Figural Paintings of David Park." *The New York Times*, January 16, 1987, p. C19.

871 Fine Arts, San Francisco. "The Triumph of the Figure in Bay Area Art: 1950–1965." September 15–December 31 (brochure, with essay by Michael Leonard).

Van Proyen, M. "Nuances of the Particular." *Artweek*, 18 (November 7, 1987), p. 1.

The Oakland Museum. "The Artists of California: A Group Portrait in Mixed Media." November 14, 1987–January 10, 1988 (catalogue, with essay by by Harvey Jones).

Brunson, Jamie. "Portrait of an Artist as a. . . ." *The Museum of California* (Oakland), (November–December 1987), pp. 9–12.

Berkson, Bill. "David Park: Facing Eden." *Art in America*, 75 (October 1987), pp. 164–71, 199.

1988 *Stanford University Museum and Art Gallery. "David Park: Works on Paper." May 10–August 14 (brochure, with essay by Betsy G. Fryberger).

Baker, Kenneth. "Park, Thiebaud Showcased." *San Francisco Chronicle*, July 7, 1988, p. E3.

WORKS IN THE EXHIBITION

Dimensions are in inches, followed by centimeters; height precedes width.

Paintings

Rehearsal, 1949–50
Oil on canvas, 46 × 35¾ (116.8 × 90.8)
The Oakland Museum, California;
Gift of the Anonymous Donor Program
of the American Federation of Arts

Kids on Bikes, 1950
Oil on canvas, 48 × 42 (121.9 × 106.7)
The Regis Collection, Minneapolis

The Letter, 1951
Oil on canvas, 30¾ × 20 (77.9 × 50.8)
Collection of Joan and Donald Fry

Portrait of Hassel Smith, 1951
Oil on canvas, 34 × 28 (86.4 × 71.1)
Collection of Mr. and Mrs. Wilfred P. Cohen

Table with Fruit, 1951–52
Oil on canvas, 46 × 35¾ (116.8 × 90.8)
Collection of Dorry Gates

Bus Stop, 1952
Oil on canvas, 36 × 34 (91.4 × 86.4)
Collection of Mr. and Mrs. James R. Patton, Jr.

Cocktail Lounge, 1952
Oil on canvas, 50 × 40 (127 × 101.6)
Collection of Harry Cohn

Profile and Lamp, 1952
Oil on canvas, 16 × 13¾ (40.6 × 34.9)
Private collection

Portrait of PGD, c. 1952
Oil on canvas, 22 × 10 (55.9 × 25.4)
Private collection

Portrait of Lydia Park, 1953
Oil on canvas, 20 × 16 (50.8 × 40.6)
Collection of Mr. and Mrs. Roy Moore

Untitled, 1953
Oil on canvas, 34 × 48 (86.4 × 121.9)
Collection of Mr. and Mrs. Mark S. Massel

Audience, c. 1953
Oil on canvas, 20 × 16 (50.8 × 40.6)
The Oakland Museum, California;
Gift of Mrs. Roy Moore

Head of Lydia, c. 1953
Oil on canvas, 25 × 24½ (63.5 × 62.2)
Collection of Helen Park Bigelow

Sophomore Society, c. 1953
Oil on canvas, 38 × 46 (96.5 × 116.8)
The Corcoran Gallery of Art, Washington, D.C.;
Gift of Lydia Park Moore

Tournament, c. 1953
Oil on canvas, 18 × 13¾ (45.7 × 34.9)
The Oakland Museum, California;
Gift of Mrs. Roy Moore

Boston Street Scene, 1954
Oil on canvas, 45⅛ × 59 (115.9 × 149.9)
Collection of Mr. Howard Lester

Jazz Band, 1954
Oil on canvas, 24 × 36 (61 × 91.4)
Collection of Natalie Park Schutz

Woman with Red Mouth, 1954
Oil on canvas, 28½ × 24 (72.4 × 61)
Collection of Arthur J. Levin

Mother-in-Law, 1954–55
Oil on canvas, 26 × 19½ (66 × 49.5)
Collection of Mr. and Mrs. Wilfred P. Cohen

Boy and Car, 1955
Oil on canvas, 18 × 24 (45.7 × 61)
Salander-O'Reilly Galleries, New York

Flower Market, 1955
Oil on canvas, 34½ × 43 (87.6 × 109.2)
Whitney Museum of American Art, New York;
Lawrence H. Bloedel Bequest 77.1.39

Portrait of Richard Diebenkorn, 1955
Oil on canvas, 20 × 14 (50.8 × 35.6)
The Oakland Museum, California;
Gift of Mrs. Roy Moore

Campus Scene, c. 1955
Oil on canvas, 16 × 18 (40.6 × 45.7)
Collection of Joseph and Dixie Furlong

Portrait of Mark Schorer, 1955–57
Oil on canvas, 16 × 10 (40.6 × 25.4)
Collection of Suki Schorer

Brush and Comb, 1956
Oil on canvas, 13⅞ × 17 (35.2 × 43.2)
Collection of Mr. and Mrs. Roy Moore

Sink, 1956
Oil on canvas, 14 × 16 (35.6 × 40.6)
Collection of Barbara and Jon Landau

Bather with Knee Up, 1957
Oil on canvas, 56 × 50 (142.2 × 127)
Newport Harbor Art Museum,
Newport Beach, California;
Gift of Mr. and Mrs. Roy Moore

Canoe, 1957
Oil on canvas, 36 × 48 (91.4 × 121.9)
Sheldon Memorial Art Gallery,
University of Nebraska, Lincoln;
Thomas C. Woods Memorial Collection,
Nebraska Art Association

Green Canoe, 1957
Oil on canvas, 52 × 40 (132.1 × 101.6)
Private collection

Interior, 1957
Oil on canvas, 54 × 48 (137.2 × 121.9)
Collection of Mr. and Mrs. Carl Lobell

Nude—Green, 1957
Oil on canvas, 68 × 56⅛ (172.7 × 143.2)
Hirshhorn Museum and Sculpture Garden,
Smithsonian Institution, Washington, D.C.;
Gift of Dr. and Mrs. Julian Eisenstein,
Washington, D.C.

The Table, 1957
Oil on canvas, 52 × 40 (132.1 × 101.6)
Collection of Mrs. Paul L. Wattis

Three Women, 1957
Oil on canvas, 48 × 58 (122.9 × 147.3)
Santa Barbara Museum of Art;
Gift of Mrs. K. W. Tremaine
in honor of Mr. Paul Mills'
appointment as Director

Bather, 1958
Oil on canvas, 22 × 6½ (55.9 × 16.5)
Collection of Allen and Frances Beatty Adler

Four Men, 1958
Oil on canvas, 57 × 92 (144.8 × 233.7)
Whitney Museum of American Art, New York;
Purchase, with funds from
an anonymous donor 59.27

Man in a T-Shirt, 1958
Oil on canvas, 59¾ × 49¾ (151.8 × 126.4)
San Francisco Museum of Modern Art;
Gift of Mr. and Mrs. Harry W. Anderson

Nude, 1958
Oil on canvas, 28⅛ × 14¼ (71.4 × 36.2)
Collection of Mr. and Mrs. Roy Moore

Portrait of Mrs. C., 1958
Oil on canvas, 18⅛ × 12¼ (46 × 31.1)
Private collection

Red Bather, 1958
Oil on canvas, 54 × 50 (137.2 × 127)
The Steinmetz Family Collection

Rowboat, 1958
Oil on canvas, 57 × 61 (144.8 × 154.9)
Museum of Fine Arts, Boston;
Anonymous Gift

Two Bathers, 1958
Oil on canvas, 58 × 50 (147.3 × 127)
Collection of Mr. and Mrs. James R. Patton, Jr.

Women in a Landscape, 1958
Oil on canvas, 50 × 56 (127 × 142.2)
The Oakland Museum, California;
Anonymous Donor Program
of the American Federation of Arts

Bather with Green Sea, 1959
Oil on canvas, 24 × 14 (61 × 35.6)
Private collection

Beach Ball, 1959
Oil on canvas, 56¾ × 60 (144.1 × 152.4)
Collection of Byron R. Meyer

Boy's Head, 1959
Oil on canvas, 32 × 26 (81.3 × 66)
Collection of Arthur J. Levin

Boy with Red Collar, 1959
Oil on canvas, 18⅞ × 16 (47.9 × 40.6)
Collection of Mr. and Mrs. Roy Moore

Daphne, 1959
Oil on canvas, 75 × 57 (190.5 × 144.8)
Collection of Mr. and Mrs. James R. Patton, Jr.

Ethiopia, 1959
Oil on canvas, 52 × 60 (132.1 × 152.4)
The Lowe Art Museum, University of Miami,
Coral Gables; Gift of Beaux Arts

Figure, 1959
Oil on canvas, 20 × 16 (50.8 × 40.6)
Collection of Mrs. Robert M. Benjamin

Four Women, 1959
Oil on canvas, 57 × 75⅜ (144.8 × 191.5)
Collection of Mr. and Mrs. Harry W. Anderson

Head, 1959
Oil on canvas, 19 × 16 (48.3 × 40.6)
Collection of Mr. and Mrs. Jimmy J. Younger

Prophet, 1959
Oil on canvas, 28¼ × 25 (71.8 × 63.5)
Collection of Mr. and Mrs. David Lloyd Kreeger

Red Man in Striped Shirt, 1959
Oil on canvas, 18 × 14 (45.7 × 35.6)
Collection of Natalie Park Schutz

Torso, 1959
Oil on canvas, 36⅜ × 27¾ (92.4 × 70.5)
San Francisco Museum of Modern Art;
Gift of The Women's Board

Two Heads, 1959
Oil on canvas, 28½ × 40 (72.4 × 101.6)
Collection of Mr. and Mrs. Harry W. Anderson

Works on Paper

Head, c. 1955
Ink on paper, 17¾ × 11 (45.1 × 27.9)
Collection of Suzanne Strid

Untitled, c. 1955
Watercolor on paper, 15 × 13 (38.1 × 33)
University Art Museum,
University of New Mexico, Albuquerque

Untitled (Reclining Male Nude), c. 1955
Ink on paper, 8½ × 11 (21.6 × 27.9)
Collection of Byron R. Meyer

Study for Interior, 1957
Watercolor on paper, 11 × 8½ (27.9 × 21.6)
Collection of Dorothy and Robert E. Duffy

Untitled (Male Nude, Foot on Stool), c. 1957
Graphite on paper, 14¾ × 12¼ (37.5 × 32.4)
Collection of Suzanne Strid

Untitled (Man), c. 1958
Ink on newsprint, 19 × 13 (48.3 × 33)
Collection of Michael Chadbourne Mills

Untitled (Woman), c. 1958
Ink on newsprint, 19 × 13 (48.3 × 33)
Collection of Katherine Lawrie Mills

Head, 1960
Gouache on paper, 11 × 8½ (27.9 × 21.6)
Collection of Mr. and Mrs. James R. Patton, Jr.

Head, 1960
Gouache on paper, 9½ × 11½ (24.1 × 29.2)
Collection of Nancy T. Park

Head with Hand, 1960
Gouache on paper, 12½ × 9¼ (31.8 × 23.5)
Collection of Natalie Park Schutz

Man in Rowboat, 1960
Gouache on paper, 11 × 8½ (27.9 × 21.6)
Collection of Helen Park Bigelow

Man Playing Violin in a Striped Shirt, 1960
Gouache on paper, 14 × 11 (35.6 × 27.9)
Collection of Mr. and Mrs.
Robert M. Montgomery, Jr.

Portrait of Richard Diebenkorn, 1960
Watercolor on paper, 10⅞ × 8¼ (27.6 × 21)
The Museum of Modern Art, New York;
Larry Aldrich Foundation Fund

Seated Figure, 1960
Gouache on paper, 14¾ × 13 (37.5 × 33)
The Morgan Flagg Family Collection

Standing Nude Couple, 1960
Gouache on paper, 15½ × 13¼ (39.4 × 33.7)
The Oakland Museum, California;
Museum Donor's Acquisition Fund

Three Women Standing, 1960
Gouache on paper, 13¾ × 20 (34.9 × 50.8)
Collection of Mr. and Mrs. Leon Campbell

Two Heads, 1960
Gouache on paper, 12½ × 12¼ (31.8 × 31.1)
Whitney Museum of American Art, New York;
Gift of Mrs. Volney F. Righter 62.56

Untitled (Scroll), 1960
Felt pen on paper, 12 × 368¼ (30.5 × 935.4)
University Art Museum,
University of California, Berkeley;
Gift of Mrs. Benjamin H. Lehman

Violinist, 1960
Gouache on paper, 14½ × 11½ (36.8 × 29.2)
Collection of Mr. and Mrs. William L. McDonald, Jr.

Woman with Baby, 1960
Gouache on paper, 14 × 11 (35.6 × 27.9)
Collection of Natalie Park Schutz

This publication was organized at the Whitney Museum of American Art by Doris Palca, Head, Publications and Sales; Sheila Schwartz, Editor; Marsha Selikoff, Associate Editor; Vicki Drake, Supervisor, Printing Services; and Aprile Gallant, Secretary/Assistant.

Design: Katy Homans
Typesetting: Trufont Typographers
Printing: Eastern Press, Inc.

Photograph Credits

Photographs accompanying this text have been supplied, in the majority of cases, by the owners or custodians of the works, as cited in the captions. The following list applies to photographs for which additional acknowledgment is due. Numbers are those of the plates, unless otherwise indicated.

Damian Andrus: 66
© E.B. Bigelow: 15, 16, 18, 20, 21, 22, 30, 31, 46, 47, 52, 53, 60, 72, 73, 74, p. 17 (upper), p. 20 (lower), p. 22
© Imogen Cunningham Trust: p. 36
M. Lee Fatherree: 10, 11, 55, 56, p. 29 (lower)
Ricardo Ferra: 6
Rick Gardner: 57
Hansen: p. 12 (lower)
Peter Harholdt: 40
Bob Hollingsworth: 3
© Kenneth F. Innes: p. 31
Robert E. Mates, Inc.: 5, 23, 27, 29, 45, 58
Gene Ogami: 44
© Douglas M. Parker Studio: p. 38
John D. Schiff: p. 21
Lee Stalsworth: 8, 49, 61, 63
George Stillman: p. 26, p. 27, p. 29 (upper), p. 30
© Vano Photography: p. 14
Martin Zeitman: 25, 50